Erwin Blumenfeld

by Michel Métayer

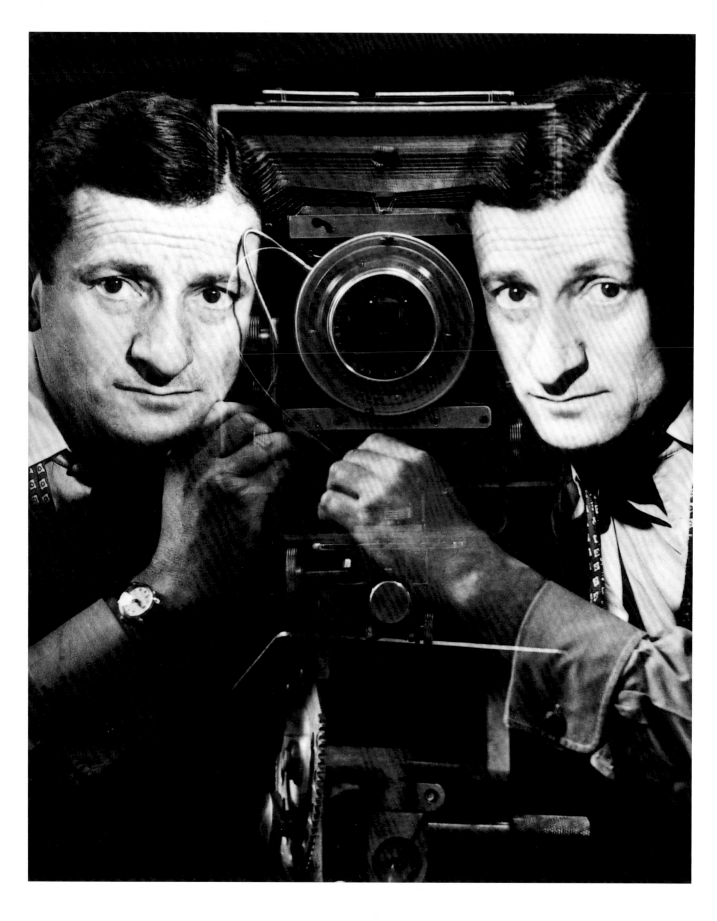

It was in his mid thirties that Blumenfeld became a photographer, partly through accident and partly through political and economic circumstances. From 1923 to 1935 he owned a leather goods shop in Amsterdam, from which he sold mostly women's handbags and whose windows he decorated with his photographs. In 1932 he moved the shop to a new location where he discovered a fully equipped darkroom. This became his first studio. After Adolf Hitler's rise to power in 1933, deliveries of leather from Germany ceased so Blumenfeld decided to persuade his female clients to let themselves be photographed. He submitted some of his work to Ullstein, the publishing house, whose blunt rejection merely served to strengthen his resolve: 'That death sentence left me cold. I knew I was a photographer.' Two exhibitions in Amsterdam, and later the appearance of his pictures in *Photographie*, the annual supplement of the Parisian journal *Arts et métiers graphiques*, confirmed his decision. By 1938, with the publication of several photographs in the quarterly magazine *Verve* and his first work for French *Vogue,* his reputation was assured.

Blumenfeld's sudden realization of his photographic gift is hardly surprising for a man of many talents. He had already tried painting and collage, written short stories and was a frequent visitor of the Dada circle in Berlin, where he befriended George Grosz, Else Lasker-Schüler and John Heartfield. Born in 1897 into a middle-class family, Blumenfeld was soon aware that his artistic sensibility was not attuned to petty-bourgeois life. His sensitivity

Erwin Blumenfeld,
double self-portrait, c. 1944

had been sorely tested when, as an apprentice in the clothing trade, he saw the working conditions of seamstresses slaving away at their sewing machines. It was stretched by his experiences in the medical corps during World War I. The duplicity of his bosses and the extra-marital affairs of his father also shocked him. Blumenfeld always valued sincerity above commercial considerations. Favouring silk, softer than wool, he would refuse to sell handbags to his clients if they chose in bad taste, instead advising them to purchase items he found more beautiful.

In the late 1950s, as he became less active in fashion photography, Blumenfeld began to reflect on his life in an autobiographical novel entitled *Einbildungsroman* (published in English as *Eye to I*, 1999). The title itself is a Dadaesque montage – the German-speaking audience would have understood both 'novel of imagination' (*Einbildung*) and 'novel of education' (*Bildungsroman*) in the tradition of Goethe's novel *Wilhelm Meister's Apprenticeship* (1795–6). Blumenfeld's ambition, however, was not to produce a rites-of-passage novel in the vein of Goethe. His *Einbildungsroman*, which was later well received by the critics, is primarily a novel about freeing oneself from all confinements: those of society, rules, indoctrination and, as ultimately happened to Blumenfeld, the concentration camp. It is a novel not of 'education' but of 'dis-education'. 'I was an anti-Wagnerian even before I was a dirty thought in my father's head,' boasted Blumenfeld in the novel. He found it necessary to detach himself from the petty-bourgeois culture that he had inherited and which initially influenced his aesthetic sensibility. Later, when writing of setting up home in Amsterdam, he noted with irony: 'Goethe's house in Weimar made a lasting impression on me in youth and for the rest of my life … we designed a bookcase in walnut to our own specifications; through the years we keep the habits of our youth.' Escaping the life his parents had planned for him was the goal that Blumenfeld set himself. Had he always obeyed his parents' wishes, had he always been respectful and grateful to them, he would have been, in his own words, 'a cretin'.

Blumenfeld's perception of reality operated first and foremost through language. He unravelled it, adding to words the ideas that they spontaneously inspired in him, ideas that he drew from the common folk-memory of songs, counting rhymes, proverbs and ready-made expressions. Blumenfeld had a feeling for formulas and he improvised on them like a jazz musician, an inventiveness he also revealed in his approach to photography. His language is filled with linguistic appropriations and word play, making it highly difficult to translate. His inventions are as intimately tied to German linguistic heritage as the rhythm of the alexandrine is to the French. Often, however, he rejected these linguistic games in favour of more grotesque play, or for a form of writing inspired by cabaret-style caricatures.

In his photography, Blumenfeld was similarly careful to avoid simply reflecting real life. His birth coincided with the advent of photojournalism, and he was fascinated with society's sudden shift from drawings to images taken from life – jostled, fluid images that outshone the comic strips of Wilhelm Busch. Yet Blumenfeld never had the instinct to record everyday life on film. Every time he felt the impulse to try, his intention was never realized: he never had a camera to hand. He concluded that he was not made for this photographic genre: 'I had a vision that made my photographer's heart tremble ... I never had my camera at the crucial moment. I am not a photojournalist.'

Blumenfeld borrowed the element of surprise from his Dadaist experiments in the 1920s and 1930s, and translated it into his pictures of dresses, hats and fashion accessories. In his photographs he raised the question of whether one can show a fashionable object without documenting it. For instance, his image of Lisa Fonssagrives (no. 17), fanning out her full dress, would not have had the same effect without the Eiffel Tower. Lisa, holding on by one hand to the iron girders and standing on tiptoe at the extreme edge of the platform, is caught in a dance movement that holds her just on the brink. She seems to float above the

empty space that we imagine at her feet. She has the grace and lightness of a dancer, but these qualities provoke the viewer's vertigo as we confront our own experience of dizzying heights. The dress is the point of departure for questioning values we associate with the visual realm. As Roland Barthes argues in *The Fashion System* (1967), the emphasis of the scene steals attention from the signified, the concept of fashion, in order to focus more precisely on the very object of fashion – the garment, an ample, generously patterned dress.

Blumenfeld resolutely embraced experimentation from the 1930s onwards. Though fashion photography was still in its infancy as a genre and offered many opportunities, it was not only this form of photography that captured his interest. His curiosity tended towards an artistic environment in which expressive languages were in constant renewal. Edward Steichen, Martin Munkácsi, Man Ray, Bauhaus, light and easily manipulated materials – each contributed to a blossoming of artistic ideas that encouraged Blumenfeld to make his photography compatible with both his financial requirements and his need to experiment with nudes and with portraiture.

Blumenfeld's photography is characterized by the use of a large variety of darkroom techniques: print solarization, superimposed images, negative–positive combinations, as well as the crystallization of the negative, dried through refrigeration. The immediate effect is defamiliarization, the creation of a distanced world. The woman's body, Blumenfeld's ultimate object of desire and fantasy, is given over to the same powers of his imagination that were at work in the title and prose of his autobiography. The body appears fragmented, a torso without a head (no. 08), or it becomes diaphanous through the process of solarization, which underlines contours while subtracting the flesh (no. 10). It can blend into the light of the background (no. 24) or be covered by a wet, translucent veil that offers tense forms to the eye (no. 11). By playing with light, colour juxtapositions and superimpositions

of different forms in the manner of the Cubists, Blumenfeld deconstructed the body's surface textures (nos. 32, 34). The body is made inaccessible, shattered into a thousand disparate points from which the image is made. These representations diffract the body, rendering it unreal and directing attention to its sensuality. The erotic reading thus suggested is born not of a sensual feeling, but through the recomposition of the image by the viewer's eye.

Photographs such as the portrait of Tara Twain (no. 06), 'The Gaze' (no. 12) or 'The Doe Eye' (no. 35), which was the cover of American *Vogue* on 1 January 1950, invite a similar reading. In the first, near frontal lighting washes out most of the surface details of the face and underlines its oval shape, light delicately accentuating the lines of the eyes and the lips. 'The Gaze' and 'The Doe Eye' no longer show anything but the essential elements: closed eyelids in the first; the mouth, eye and beauty spot in the second – the colours added later by *Vogue*'s art department. In the later two photographs, a face remains present but the elements that make a psychological portrait have disappeared.

For commissioned portraits, Blumenfeld applied more traditional techniques. For twenty years, first in Paris and then in New York, composers, painters, writers, actors and fashion designers called upon his skills, including Henri Matisse, Cecil Beaton, Eugene O'Neill, Marlene Dietrich and Grace Kelly. The painter Matisse (no. 13) is pictured full-face in front of one of his paintings: his eyes are fixed firmly upon the lens, which he examines medita- tively. Cecil Beaton (no. 14), with his fine traits and delicate face, seems absent, absorbed in the consideration of an object we cannot see. A character in the background tapestry is also looking at a point outside the frame, in a reverie analogous to that of the principal subject. Marlene Dietrich (no. 49) and Eugene O'Neill (no. 31) are subjects of full-length portraits: Blumenfeld accen- tuates the long silhouette of the former, yet squashes the latter in his chair, reducing him to a body entirely given over to

nervous energy. In contrast, Blumenfeld's photograph of Grace Kelly (no. 39) marks the limit of psychological portraiture. The pose is dictated by the requirements of the commission: a simulated expression of relaxed calm melts into the pink, which colours the objects and allows nothing but the blonde of Kelly's hair to appear.

In Blumenfeld's view, portraiture was a difficult art that was made all the more arduous if the model was attractive. Invited in 1937 to take the portrait of his first art director's mistress, the beautiful Hélaine, he later described the great pleasure he found in this task. 'For the whole of a marvellous afternoon, I struggled to steal the loveliness from this beautiful woman. It is harder to take the beauty from a lovely woman than to make an ugly one more attractive. Hélaine was a beauty who defied all description, but divine women never desire the beauty I find in them. It takes them decades to become one with their portraits. A good portrait needs time: the model ages, the photo stays young.' Almost all of Blumenfeld's portraits, like his more experimental work, would remain unknown to the general public during the artist's lifetime.

It was in fashion photography that Blumenfeld made his strongest mark. Though he started working in black and white in 1938, after his return to New York in 1941 he took up colour enthusiastically in response to the demands of his employers: American *Vogue*, *Harper's Bazaar*, *Life*, *Look* and *Cosmopolitan*. Yet Blumenfeld never abandoned his experimentation with black-and-white photography. Black-and-white and colour photography were for him not only completely different techniques, but also different media suggesting entirely distinct modes of expression. In black-and-white photography, the taking of the picture is only the first moment in a process that continues through the entirely personal craft of the darkroom. His colour photographs, on the other hand, were processed by laboratories over which he had little control, at least until 1955

when he started to experiment with Cibachrome, a test that he ultimately found disappointing. The two techniques have different uses and contexts: his black-and-white photographs are the result of personal initiative and show constant experimentation at every moment in their realization, as was the case with the portrait of Hélaine. In contrast, Blumenfeld's colour photography was almost always the result of commissions and had to respond to the desires of an art director, whatever inventiveness and enthusiasm might have influenced the framing of the shot.

In the mid 1930s, improvements in the quality of magazine and film colour printing allowed colour photography to enter into a different relationship with reality to that which had been customary in black and white. The difference between the colours a photographer believed he was capturing when the picture was taken and those present in the final reproduction becomes obvious when the pictures are finally printed. Moreover, certain nuances of colour fit with different contexts, correspond to different habits and changing tastes. Added to this are the effects of unbridled competition between different editors and art directors in the commercial world of magazines. Their power was stronger than Blumenfeld initially imagined: 'Robert Guesclin was my first art director. I thought that it was a joke when I heard these words for the first time. Not so. It seemed unthinkable to me that someone else's hands, those of an art director, could manipulate my ideas, my work, my photographs – could emasculate and bastardize them and then approve them for publication.' Later, in New York, the situation would further deteriorate: the 'art director' (in German, *Artdirektor*) would become the 'arse director' (or *Arschdirektor*). The portrait Blumenfeld offered of Carmel Snow, the chief editor of *Harper's Bazaar*, was similarly pitiless: 'An infallible sense of couture founded on a total absence of culture. The most cunning fashion journalist of all time. Both stimulating and repellent. Miserly in the extreme if one were asking her for help, astoundingly generous if she needed help from others.

She would have killed her old mother in cold blood – so her secretary proudly told me – if it would make for a good page in the *Bazaar*.'

Carmel Snow had fired Adolf de Meyer, whose style she found anachronistic, and in 1934 brought in the Russian designer Alexey Brodovitch. Both Snow and Brodovitch refused banality, easy effects and repetition: each photograph had to be new and inventive. Brodovitch also redesigned the layout of the magazine, adding a great deal of colour. Blumenfeld benefited from these changes during his first stay in New York in 1939, when he signed his first contract with *Harper's Bazaar*, and after he moved definitively to New York two years later.

The many photographs Blumenfeld created for *Harper's Bazaar* and, after 1944, for *Vogue* were all intended to promote commercial products: clothes, lipstick and make-up. Their strategy is indirect: they create atmospheres, nuances and textures that crystallize attitudes and tend to draw out traits of character. It was in this context that Blumenfeld developed his colour vocabulary and added to it a number of shades. Carmine red was of great importance: less concentrated than vermilion, which he used for certain contrast effects, his carmine often comes close to ultramarine and pink. Nonetheless he could also be violent in his use of these shades, exerting on the eye an ambiguous, simultaneous effect of attraction and repulsion. In 'Red on Red' (no. 47), for example, Blumenfeld comes close to melding the model's hat and coat into the carmine of the background. The model, seen from the back, is turning around and looking at the lens. All that stands out from the carmine, as if cut out from the backdrop, is a practically smooth face with only the eyes and the mouth, whose vermilion stains the totality of the composition. 'Woman with Parasol' (no. 36) presents a similarly subtle choice of colours: the image is composed of various nuances of yellow. The parasol, the glove and the hat are the lightest elements, while in the upper part of the photograph the background takes

on a slightly ochre hue, balancing the coat. The subtle play of harmony, hue for hue, subtracts the situation from any here and now, giving it an unreal look and – despite the absence of movement – imbuing it with the quality of an apparition.

In these two images, as in most of Blumenfeld's colour photographs, a commercial purpose is not immediately apparent. Though the subject is, perhaps, an assortment of different ensembles made up of an overcoat and a hat – one for winter and one for summer – nothing makes this explicit. What is at stake here is the use of an elaborate palette. In *The Fashion System*, Barthes explains that 'colour signifies, not in and of itself, but inasmuch as it is marked or not marked', and that 'bright, light, frank, brilliant colours' are opposed to those which are 'dark, sombre, muted, neutral or faded with time'. In this sense, Blumenfeld 'marks' the colour in order to provide visual surprise. Colour becomes the articulating principle of his photographs: it gives consistency to the movement. In the middle of apparent uniformity, in which attention might wander, colour concentrates the glance on the nodal point of the image, for instance the eyes or the lips. 'Jacques Fath Dress' (no. 44) addresses us with a mischievous allusion. O's lips (no. 43) pronounce for us the 'O' of poet Rimbaud's 'Vowels'. The lips are captured at the point of their greatest tension: the fragility of the moment is transmitted through the alternation of stripes that cross them and the reflection of light on the carmine. In 'Blue Veil' (no. 37), the model's face advances towards us, occupying the whole of the visual field, without removing the veil that separates her from us. As in 'The Doe Eye' (no. 35), movement and montage are the elements from which meaning is constructed. It is this game of seduction that Blumenfeld introduced into image culture, a game so often taken up later by the likes of Irving Penn, William Klein, Paolo Roversi and David Seidner, whose portrait of Prudence Walter is entitled 'Homage to Blumenfeld'.

Blumenfeld's photographs were intended for magazines. They appeared on the cover or inside *Harper's Bazaar* and *Vogue*

amongst many others. Only much later were some of them exhib-
ited. Several photographs, proposed by the artist to editors who
refused them – for example, a version of the photograph in which
Dovima poses behind a rippled glass pane (no. 45) or 'What Looks
New' (no. 32) – appeared posthumously in William A. Ewing's
Blumenfeld: a Fetish for Beauty (1996). 'What Looks New', intended
for a lipstick advertisement, was replaced by a version with more
obvious colour contrasts. In the new version, the face and scarf
are moved into the left half of the image between two slightly
oblique lines. They come out of a dark brown background into
which the hat melds. The Cubist decomposition of the face is
less troubling, the face is more easily distinguished and the mouth
takes on the luminosity and sensuality of the kumquat lipstick.
The version shown here must have seemed too complex to the
art director, too subtle for an advertisement.

By the end of the 1940s, Blumenfeld was the highest paid photo-
grapher in the world. Nevertheless, he detested being considered
a commercial photographer. Though Blumenfeld was celebrated,
his photographs did not inspire monograph studies and he felt
much more comfortable in the world of fashion. 'Under Cecil's
[Beaton] wing I soon got into the *Vogue* establishment, and quickly
learned to despise that philistine vanity fair, in which small-ad
profiteers pretended to be arbiters of elegance. Illusions are there
to be shattered. In that ants' nest of unrequited ambition, where
nouveautés have to be pursued *à tout prix*, I remained – in spite of
a thousand pages of published photographs – an outsider, a foreign
body.' The image he had of New York and of the United States
is not unrelated to this commercial situation. For Blumenfeld,
the United States was 'an expression of power and not a *chef
d'oeuvre*', its culture was that of 'a band of newly wealthy bandits
playing at café society'. This vision was confirmed by a meeting
with George Green, the CEO of the largest American publisher
of almanacs and, in Blumenfeld's eyes, one of the unscrupulous
representatives of the world of image commerce, who personi-
fied the barbarism and extreme puritanism of American society.

Blumenfeld formulated his critique in cultural terms, but it is really a political one. For him, any undistanced attachment to an idea was like a religious phenomenon: attachment leads to pre-programmed suicide. *Sequere deum* ('follow your destiny') is how Blumenfeld paradoxically described the distance he took from such phenomena. The examples he used to illustrate this precept in his autobiography show how he always refused to let himself be prisoner either to the heroism of 'dying for one's country', which the schools tried to inculcate in him, or to the heroism of 'dying for ideas', which he learned from his family. To 'follow your destiny', for Blumenfeld, was to insist upon freedom of thought, to resist thought's alienation through 'common sense' or the fanaticism of the crowd.

As a Jewish émigré, a failed shopkeeper, a photographer just starting out, at every moment Blumenfeld was confronted by the duplicity of language. His experiences taught him that the words 'reception for foreigners' really meant 'concentration camp'. Though, in the greatest Romantic tradition, he was ready to risk his life in the fight against barbarism, he turned himself in to the French police instead of fleeing and was interned in a camp for several months. Later, after the Liberation, he noticed that the vacuity of language had emptied law of all content: 'Marianne [the symbolic female representation of France], the big whore, who committed outrages against human rights, was never bothered.'

Blumenfeld lived both outside reality and inside it. He let himself be fooled by illusions even when he was aware of them. He knew the duplicity of language but nevertheless allowed himself to be taken in by it. A dreamer and an idealist perhaps – though, just after his arrival in Paris, Blumenfeld already looked upon French society, as he would later regard the world of magazine publishing in the United States, with a realistic eye unfettered by conventions. In Parisian prostitutes he saw 'hardworking, industrious girls' who 'only prostitute themselves for their work,

as we all do'. Leaving aside all moral judgement about their profession, he turned his criticism on the society that judged them, believing that it is not prostitutes who are morally lacking, but rather those faced with such practices who retain a hypocritical attitude. 'I, in any case, was a foolish libertine with a double moral compass: I venerated lowly women as saints, and resented it when my saints fell down to the ranks of dancing women.' This anecdote shows how sensitive Blumenfeld was to the ambiguities of the world: it suggests without telling, seeming to turn away from the real in order better to return to it.

The dictum 'follow your destiny' means to abandon oneself to the moment without being fooled by it. Such an experience is filtered through two elements: eroticism and time. Even as a child, visiting the great museums of Berlin, Blumenfeld saw in art the free expression of his desires. Models, orgies, nudes half-hidden behind veils, all seduced him, but he was also sensitive to beauties with souls, and to the warm and lightly trembling atmosphere of Impressionist paintings. It was here that the sensual world of his photographs coalesced. 'I dedicated myself resolutely, vigorously, to the fetishes of my love: eyes, hair, breasts, mouth.' He never forgot, however, that the world is a memento mori. In 1969, before his own death in Rome, Blumenfeld's experience of the senses and of the moment renewed itself one last time in a scrutinizing, almost poetic narrative of his first heart attack five years earlier: 'Wet breath rained hammer blows on my heart, teeth threatened to stick in my throat, bones crumbled, sweat fell as pearls before swine, mucus-filled guts left me revoltingly [sic], my eyes stared impotently into nirvana, the thin thread broke, all was past: I was dead.'

　　　　1911　　｜　My First Self-Portrait, as Pierrot, Berlin.

This self-portrait is Blumenfeld's earliest existing photograph. His uncle, a photography enthusiast, had given the ten-year-old Blumenfeld a 9 x 12 cm camera with 'an ultra-fast anastigmatic lens, anti-glare glass, a red rubber shutter bulb, tripod and metal carrying case'. Blumenfeld later wrote, 'I had been, for as long as I can remember, hypnotized by photography equipment. The 9 x 12 format got into my blood; it became my format.'

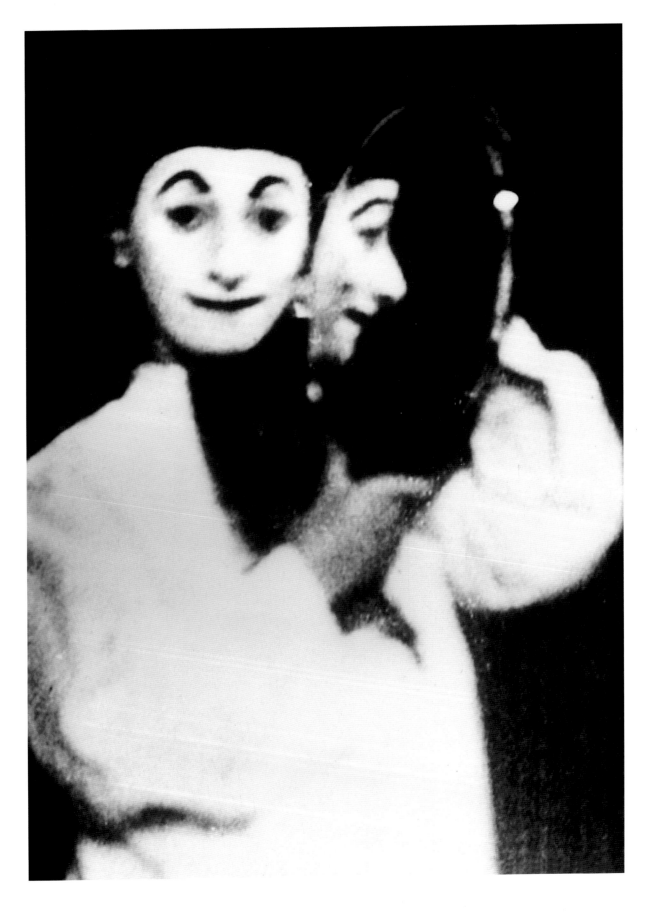

1925 | My First Son, Zandvoort, the Netherlands.

This self-portrait shows Erwin with his eldest son, Heinz, later renamed Henry. In December 1918, Blumenfeld moved from Berlin to Amsterdam and in 1921 married the cousin of his best friend, the painter Paul Citroën. Unable at that time to make a living in the field of contemporary art, he opened a shop – the Fox Leather Company, mainly selling women's leather handbags – at Kalverstraat 116. At this point, photography, like painting and writing, remained only a hobby.

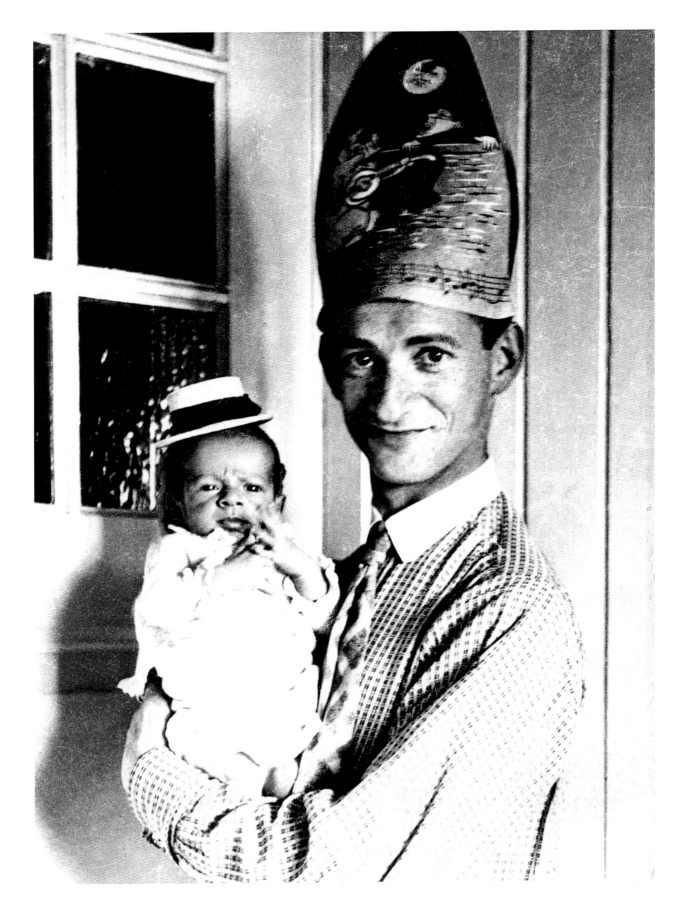

c. 1932 Gypsy with Child, Southern France.

This photograph was taken on a trip to the South of France, most likely at
Saintes-Maries-de-la-Mer, a town in the Camargue region where gypsies
meet annually. Before leaving Paris at the start of World War II, Blumenfeld
hid all his negatives under his bathtub. When his friend the model Jo
Sandberg recovered them seven years later, he found the negative of this
image had been damaged by water. By happy coincidence, the printed
photograph suggested the texture of a fresco.

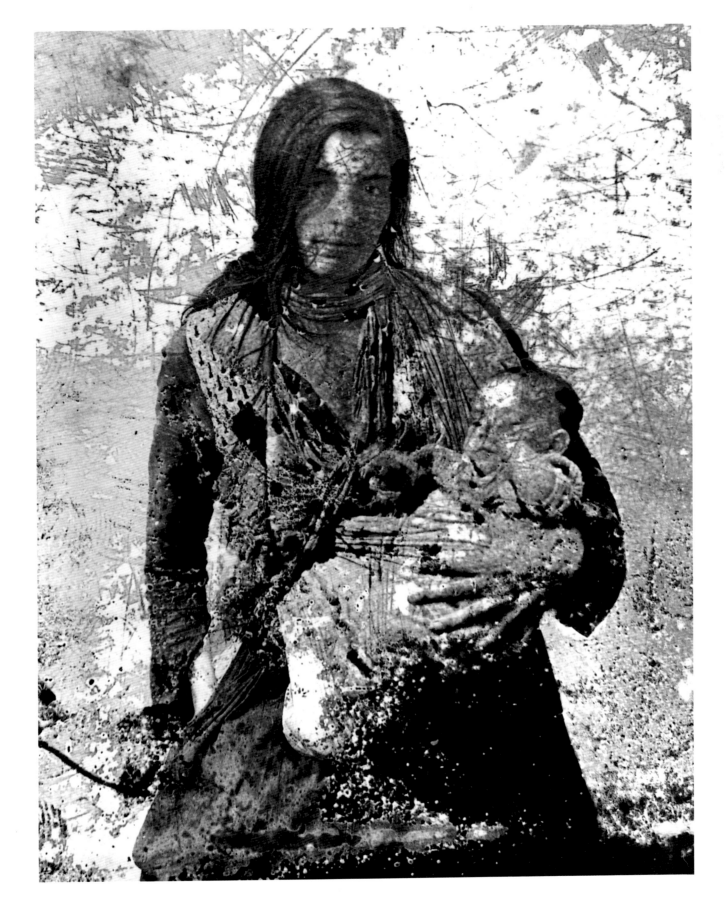

1933 Hitler's Ugly Mug, Amsterdam.

In 1932 Blumenfeld moved his shop to Kalverstraat 151, Amsterdam, but with Hitler's rise to power, business faltered. 'More than to anyone else, I owe a debt of gratitude to the *Führer Schicklgruber*. Without him, I would have rotted away in the Dutch marshland; without him I would never have had the courage to become a photographer ... By way of thanks, on the night he seized power, I made a photomontage of his gruesome mug with a skull ... In 1942 millions of copies of this photograph were dropped over Germany as American propaganda leaflets. *Heil Hitler!*'

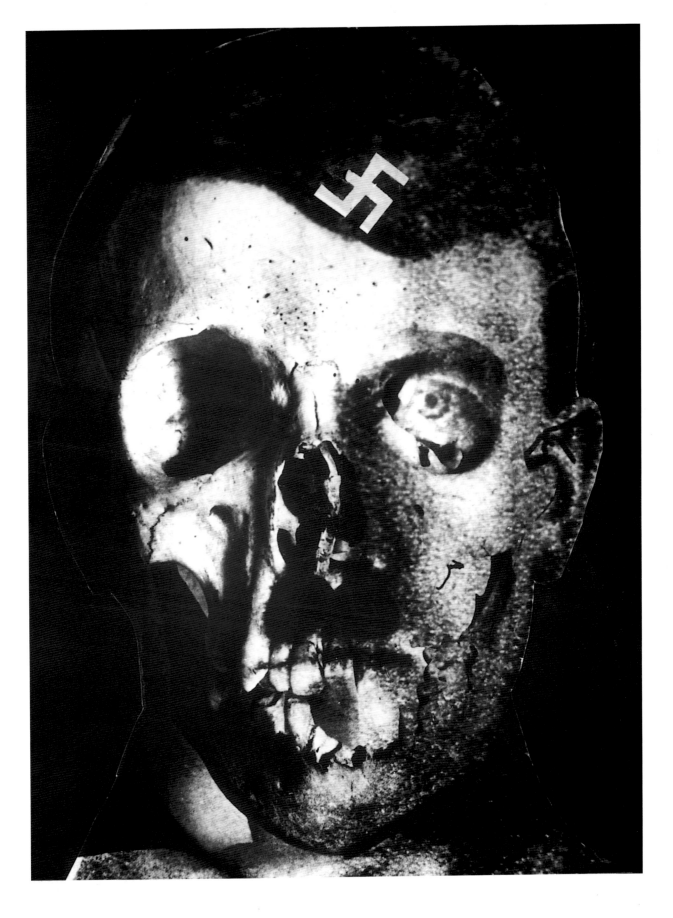

1933 | Black and White, Amsterdam.

Slowly but surely, Blumenfeld gained recognition as a photographer. One day, this American couple visited his leather goods shop and Blumenfeld persuaded them to pose for this portrait. The couple's faces reflect each other as if in a mirror. Despite the relative lack of interest in photography in the Netherlands at the time, Blumenfeld was already experimenting, creating this unprecedented composition.

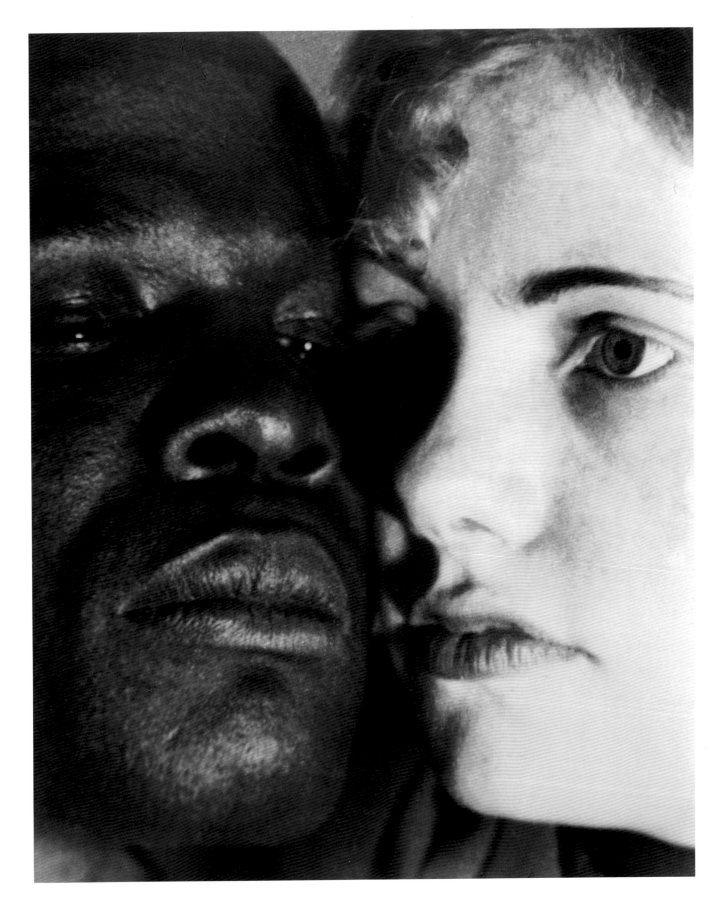

1935 Tara Twain from Hollywood, My First American Woman, Amsterdam.

At his handbag shop on Kalverstraat 151, Blumenfeld discovered a darkroom behind a blocked-off door. 'Out of the body of my "FOX", as it bled slowly to death, there blossomed a bellows camera (a Voigtländer "Bergheil") and above it glowed a lamp of ruby-red. I developed and printed all night long so that every morning a new and angelic face in "high key" could shine forth in the shop window amongst what was left of the crocodile-tears handbags. My first American lamb to the slaughter, Tara Twain from Hollywood, became my first publication, *mon premier pas: Arts et métiers graphiques*, Paris, 1935.'

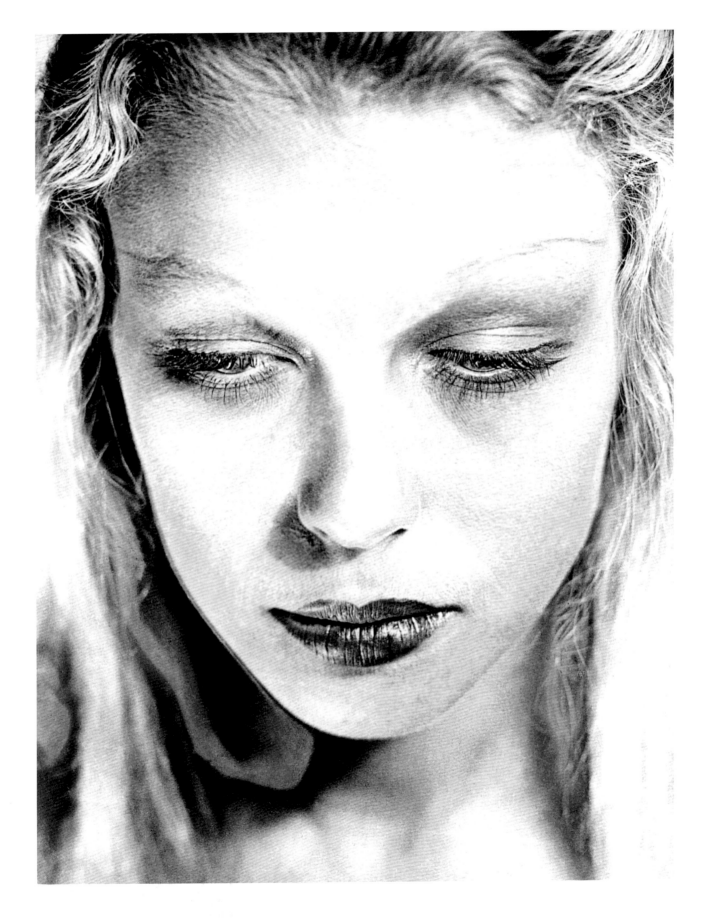

c. 1935 Hair, Amsterdam.

'Hair hides: it is both promise and seduction. The promise that a woman still has other faces, and among these the face of seduction, the face with which she is no longer a bookseller, a businesswoman, a lawyer or anything else, but simply a woman' (*Vogue*, July 1939). Just as he described it, the flowing hair of a thrown-back head was one of Blumenfeld's favourite motifs, which he used frequently in his commercial photographs.

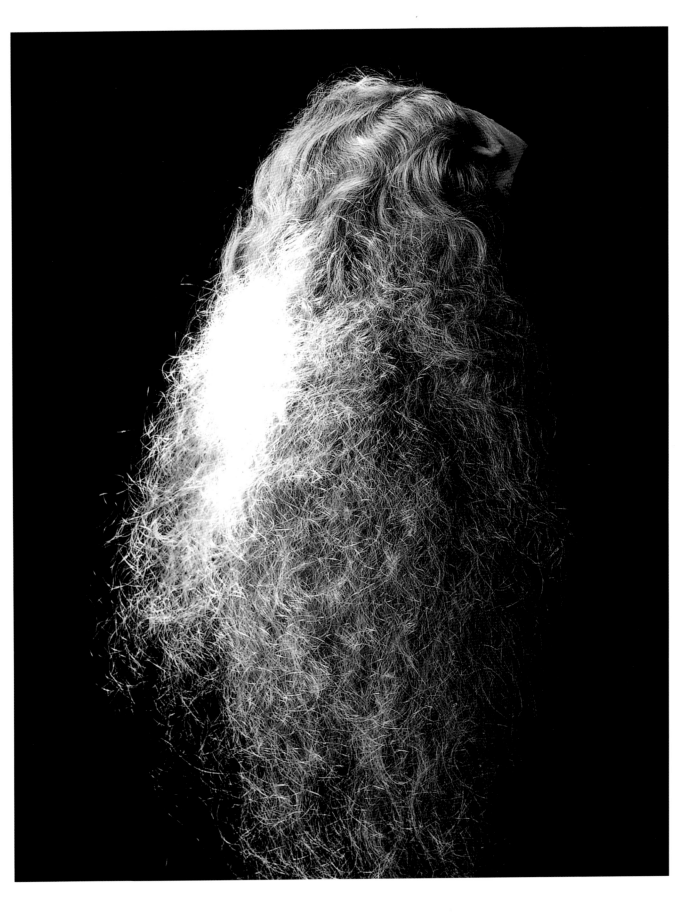

c. 1936 Torso, Paris.

In January 1936 Blumenfeld moved to Paris, setting up in a mansard room in the Hotel Celtic, rue d'Odessa. In order to earn a living, he divided his time between taking portraits and commercial photographs, yet his principal desire was to be recognized as an artist. This torso can be read in the classical tradition of representation, but Blumenfeld rids the image of the constraints imposed by context. Here, he extracts forms and lines from the traditional motif, and gives them new existence.

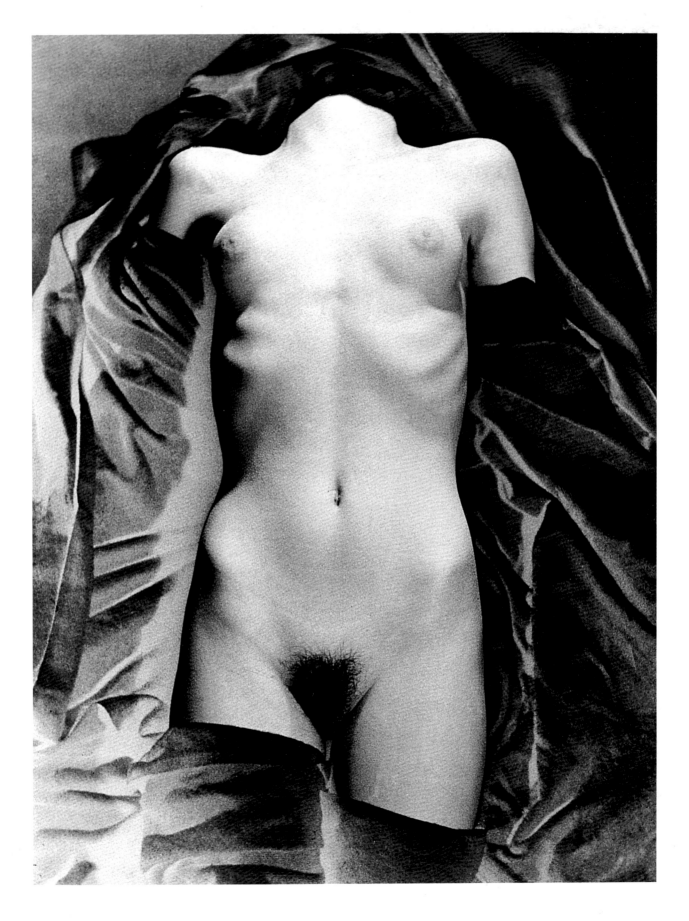

c. 1936 | The Dictator, Paris.

The rise of the Nazis alarmed Blumenfeld – a self-portrait in 1933 shows his forehead marked with a swastika, a disturbing premonition of the concentration camps. Hitler was his favourite target, appearing as a rotting skull (no. 04) and here as a minotaur: a calf's head mounted on a bust of Venus. Apparently, when presented at an exhibition in Paris, this photograph incurred the wrath of the German ambassador who demanded its removal. Several years later, the French painter and poet Francis Picabia used the motif in his painting *Adoration of the Calf* (1941–2).

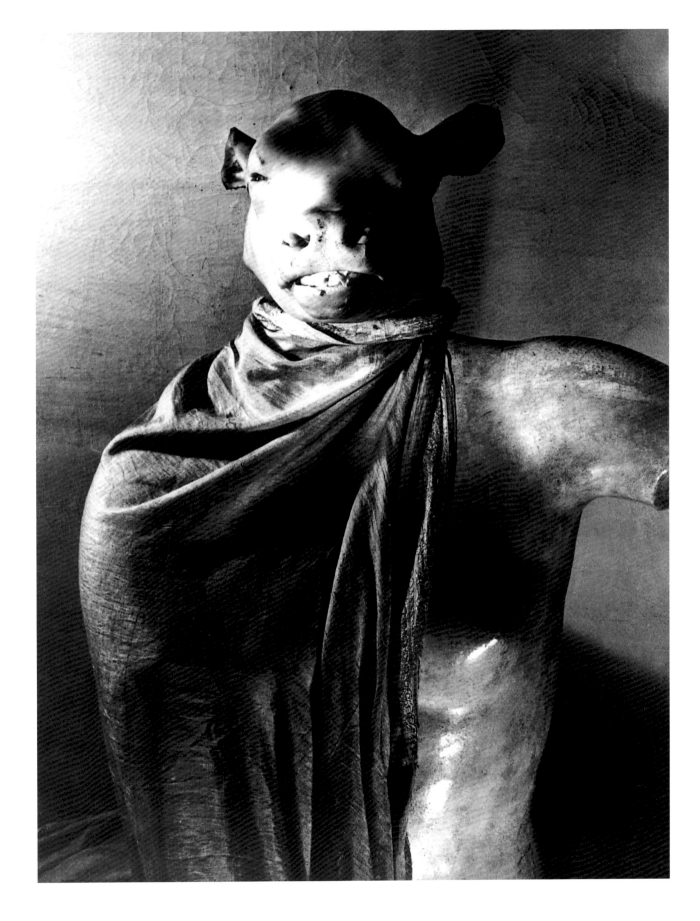

10 1937 Back, Solarization, Paris.

The Parisian period was rich in all sorts of experiments; Blumenfeld is, as the critic Tom Hopkinson has suggested, an 'image maker'. The darkroom is his universe. Here, he combines a classical pose and the modern alchemy of solarization. This nude shows the technical influence of Man Ray: 'The answer to my dreams was to be a photographer, full stop. Art for art's sake, a new world, successfully discovered by this American Jew, Man Ray.'

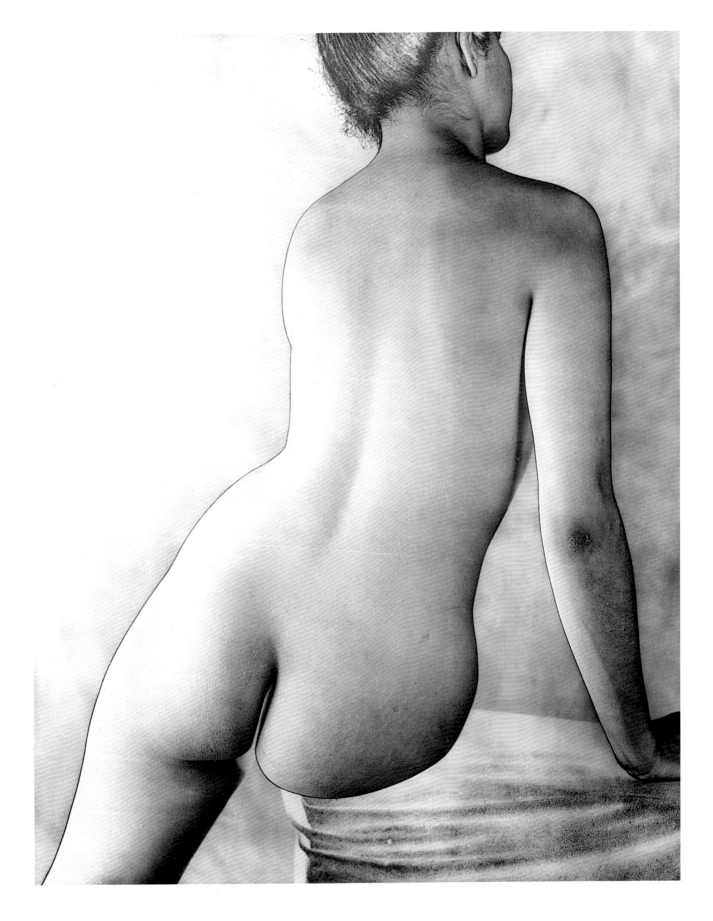

1937 Nude Under Wet Silk, Paris.

The publisher Tériade, who had left the Surrealist journal *Minotaure* for the sumptuous quarterly magazine *Verve,* was impressed by Blumenfeld's work. Tériade published several of his photographs, including this one, in the first two issues of *Verve.* They were placed next to those of Man Ray, Brassaï and Ubac. Such prestigious company and the excellent quality of the reproductions constituted Blumenfeld's first recognition by the art world. Other photographs appeared in *Photographie* and *Lilliput* and about fifty were sold to the American magazine *Coronet.*

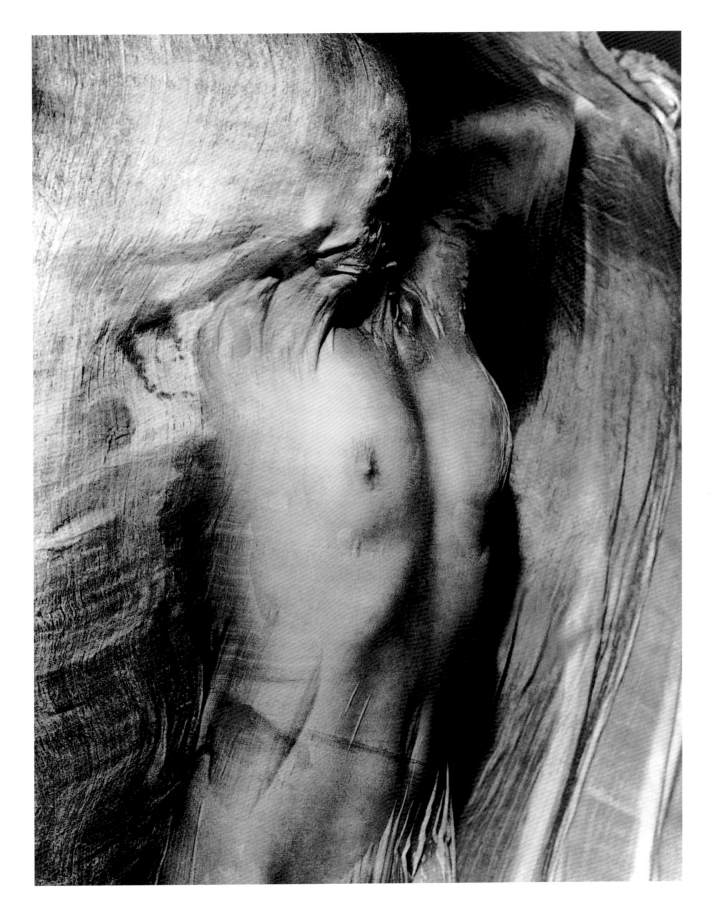

| 12 | 1937 | The Gaze, Paris. |

In Blumenfeld's autobiography *Einbildungsroman*, this image has the title *'Der Augenblick'* ('The Moment' or, literally, 'The Eye's Gaze'). During printing, the features of the face as well as the shadows of the eyes were eliminated. All that remains on the white surface of the paper is the outline of the closed eyelids and the eyelashes – the negative of the gaze. Experiments with empty space and lines are one of the constant themes of Blumenfeld's work.

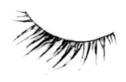

1937 Henri Matisse, Paris.

Geneviève, the daughter of the French painter Georges Rouault, inspired Blumenfeld to set up in Paris in order to conquer the capital as a fashion photographer. She introduced him to artists, such as her father and Henri Matisse, whose portraits he would later make. 'At that time, I made definitive portraits of Rouault and Matisse. Like true prima donnas, they both grumbled that I had made them look older, and promptly drew rejuvenated self-portraits based on my photographs.'

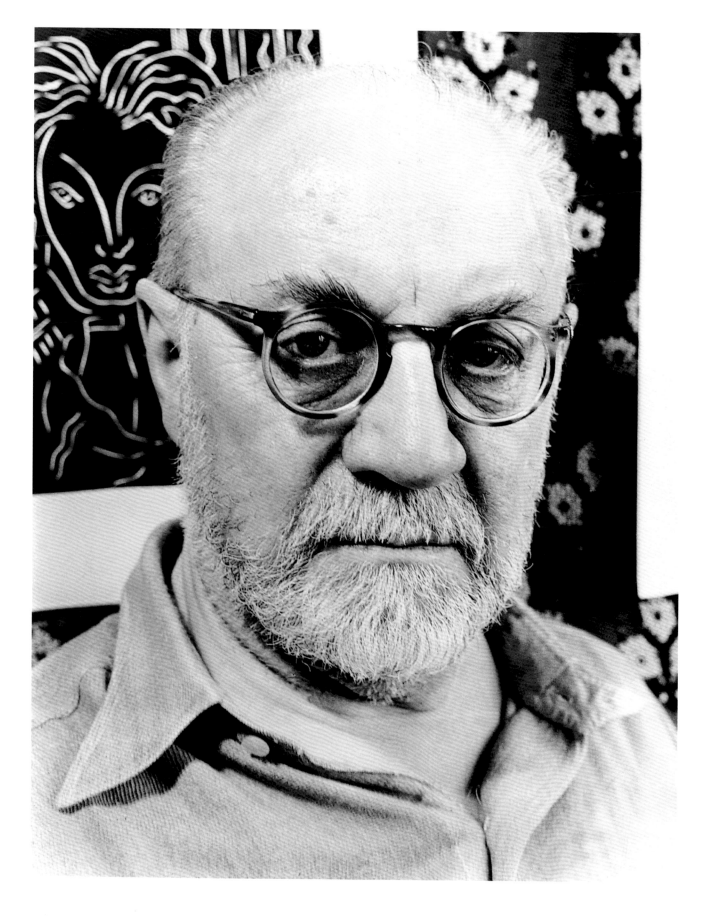

1938 Cecil Beaton, Paris.

In 1938 Blumenfeld met the British photographer Cecil Beaton, who pro-
nounced as 'divine' the portraits Blumenfeld had made of the Countess de
Noailles's daughters. Beaton obtained a contract with *Vogue* for Blumenfeld,
and wrote in his diary: 'Here, finally, is someone who has never been influ-
enced by the work of another photographer. This is a fresh, clear spirit ...
He has made a series of nudes, of reclining women covered with wet
drapery, more beautiful than French Renaissance sculptures ... This is
something completely new and infinitely touching.'

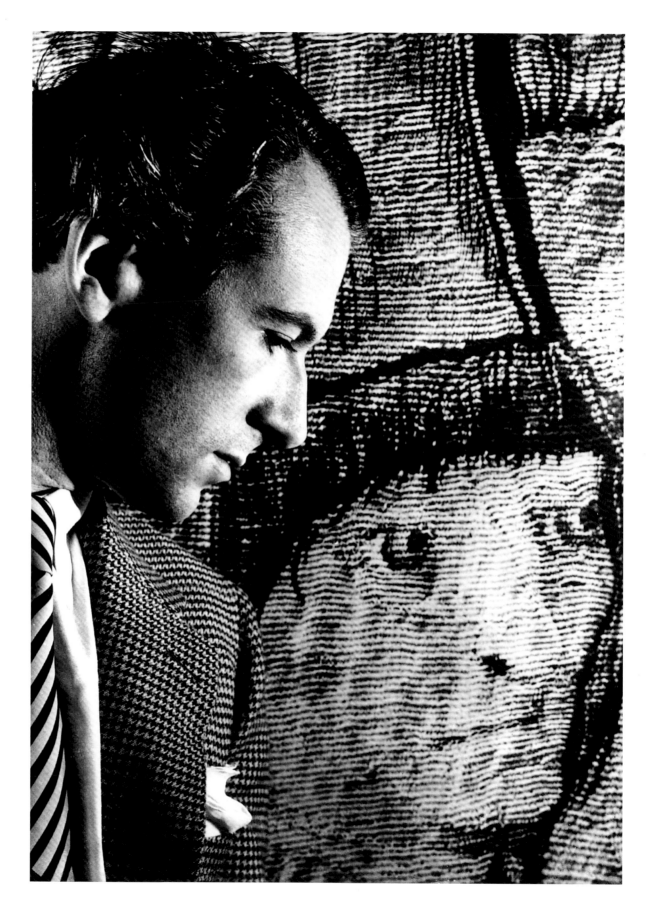

1938 9, Rue Delambre, Paris.

This space, a stone's throw from the Café du Dôme where artists often met,
became Blumenfeld's studio in 1936. The image is a self-portrait of the
artist in his studio, surrounded by his photographs. 'Each picture is a novel.
All my portraits encapsulate my gaze. Every artist lives from variations on a
single theme. Whether he writes by hand, or with his foot in the sand, the
writing remains the same.'

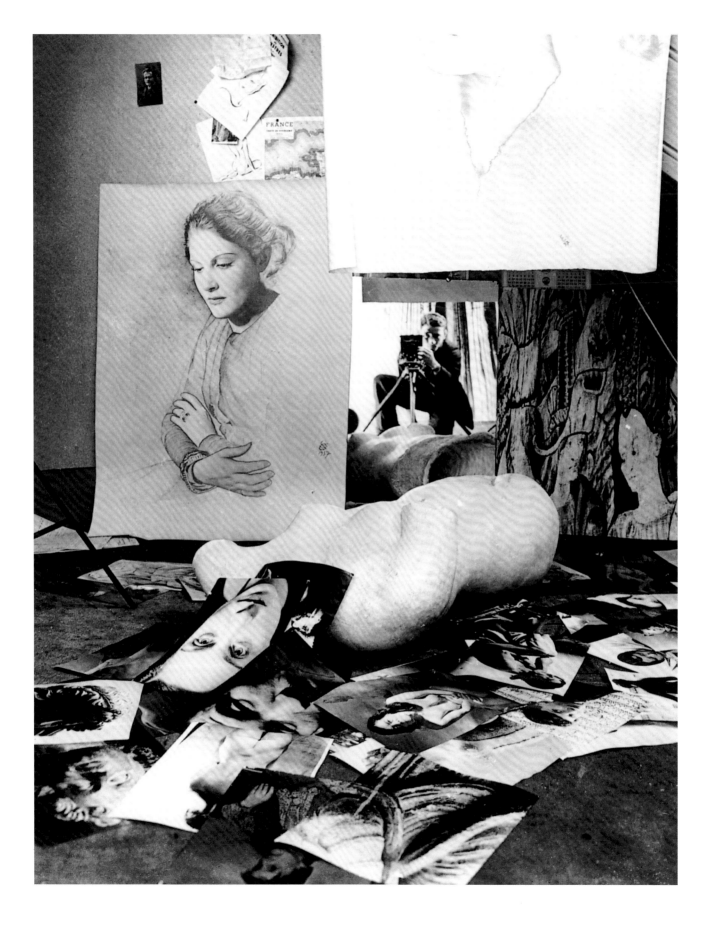

1938 Nude in the Mirror, Paris.

Compositions with mirrors are common in Blumenfeld's work. In many images, they provide a double vision – of the full face and of the profile. 'Mother had taught me that the eye was the mirror of the soul ... Even if, in the meantime, I had learned that the opposite was the case, I remain persuaded that, behind the transparency of glass, another life in another world is being played out. We are doubles. Without a mirror, I would never have become a man. Mockers might call this a Narcissus complex: no art without a mirror, no music without an echo.'

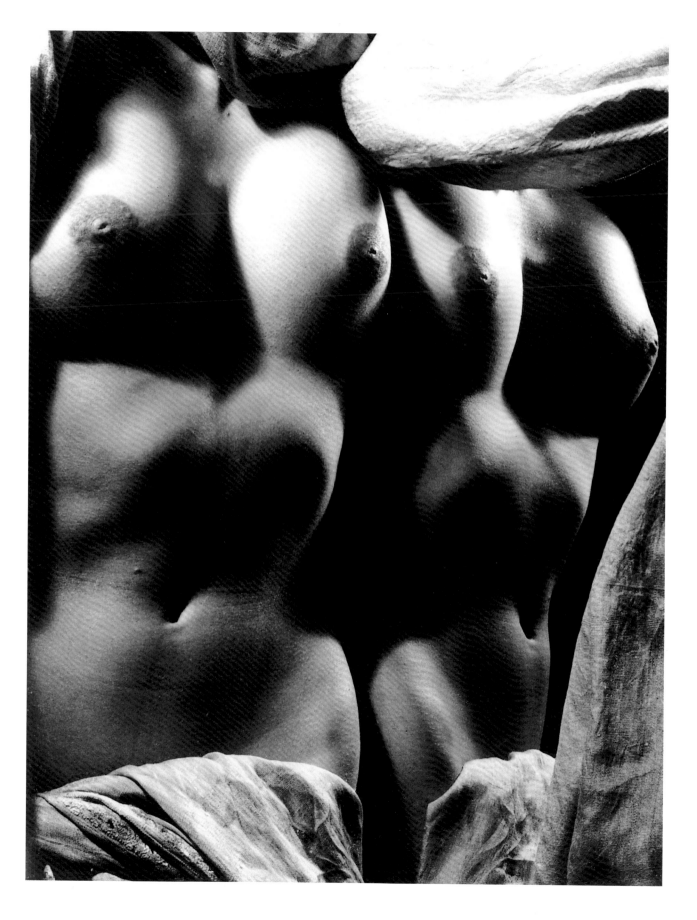

17 May 1939 The Eiffel Tower, Paris.

In October 1938, French *Vogue* devoted a portfolio to Blumenfeld's fashion photography. Other photographs appeared in February and March 1939. The May 1939 issue was taken up by the fiftieth anniversary of the Eiffel Tower. The principal piece in this series is presented here. Despite this brilliant composition, the one-year contract Blumenfeld held with *Vogue* was not extended, and he left for New York. The dress is by Lucien Lelong.

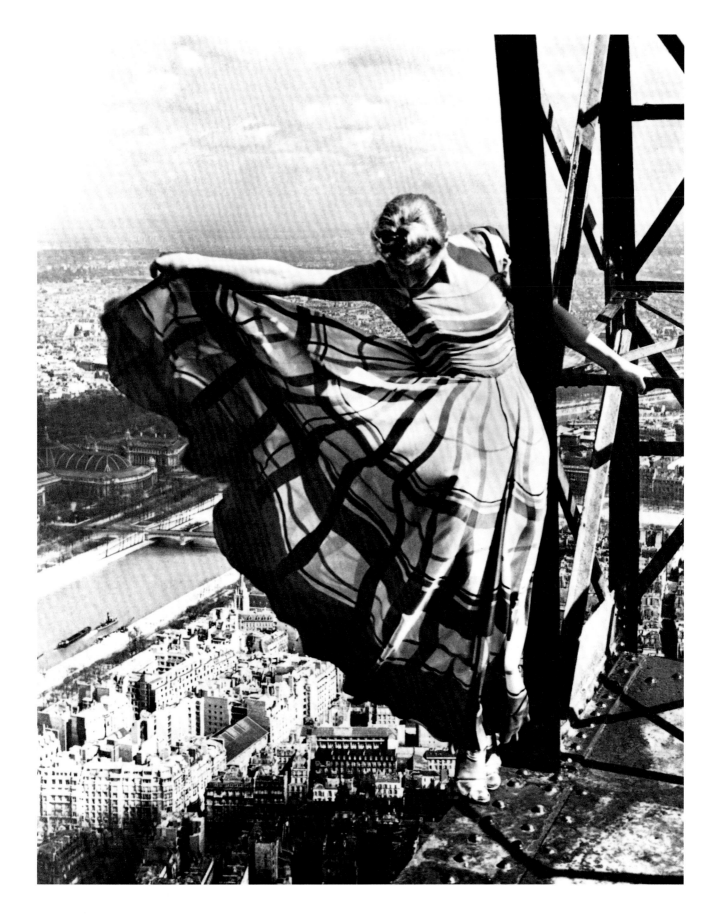

1942 Untitled, New York.

Having returned to France just before the outbreak of World War II,
Blumenfeld was put under police surveillance and eventually interned
in a concentration camp as a foreigner. In 1941 he managed to leave
German-occupied France for New York, where, for two years, he shared
the photographer Martin Munkácsi's studio near 50th Street and the
East River. This photo of model Natalia Pasco was taken on the balcony
of their shared studio. It is one of Blumenfeld's few photographs taken
in front of a natural background.

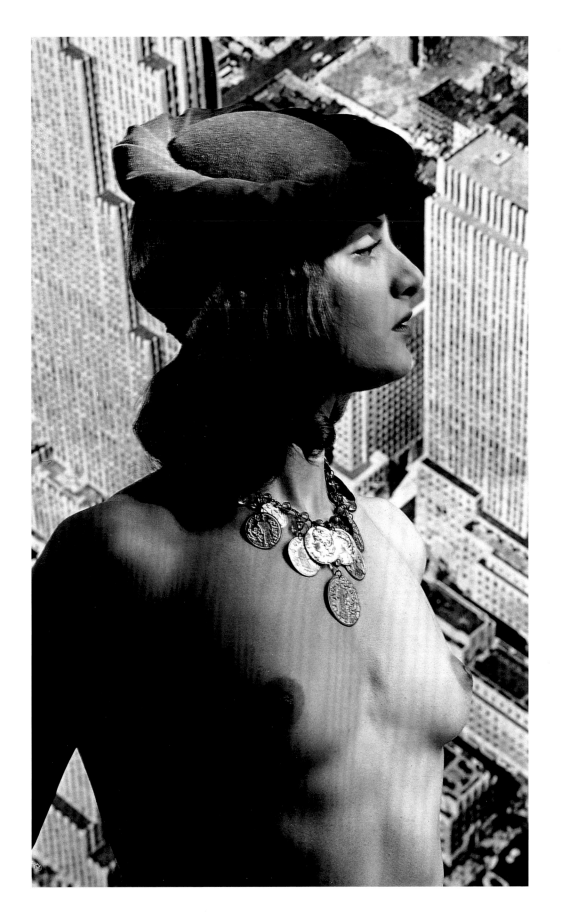

1942 After Raphael, New York.

Natalia Pasco was one of Blumenfeld's favourite models and he made hundreds of photographs of her, many portraits but even more nudes. The image shown here recalls Raphael's self-portrait. Aside from the depth of Blumenfeld's visual culture, what is striking about this portrait is his magnificent gift for individualizing his models, even when their lives are unknown to the viewer.

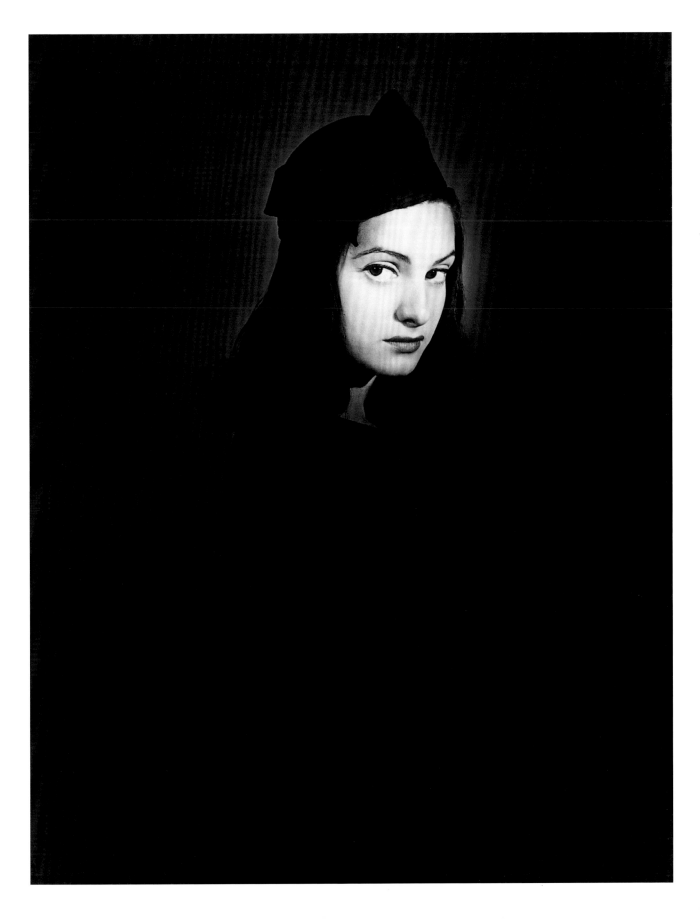

1943 Nude, New York.

Blumenfeld combines two possible views in one image. The overall graphic line of the body is that of a cross. Yet the eye is also attracted by the play of shadows on the skin: a grid, placed between the light source and the model, projects the mesh shadow of a net and cuts up the silhouette into an infinity of diamonds. The viewer's eye hesitates between the variations of this pattern and the movement of the subject.

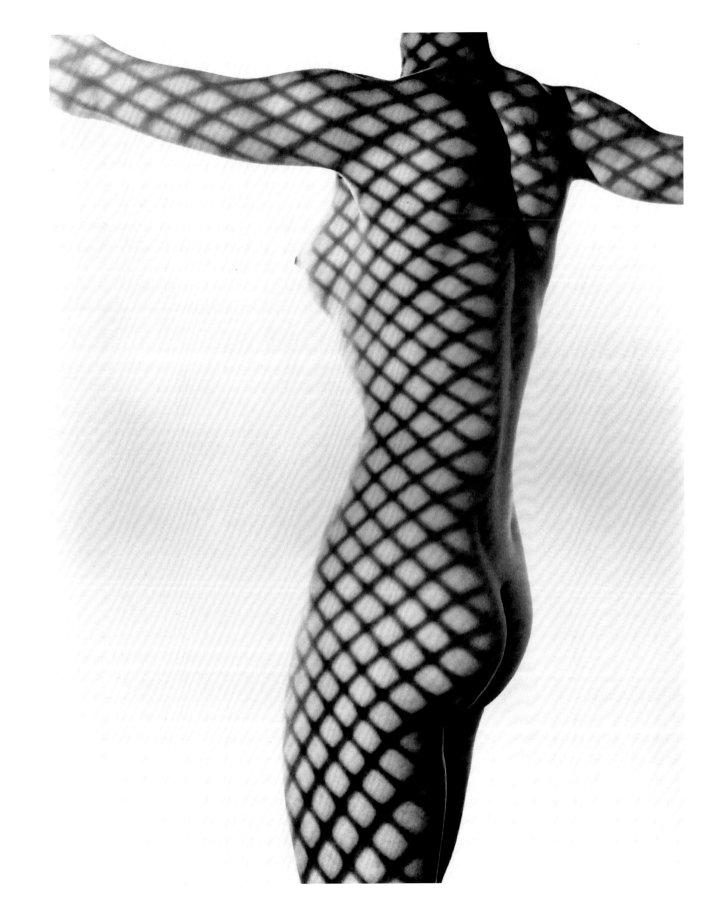

1944 Nude, After Prud'hon, New York.

Despite the similarity of the poses in this and the preceding black-and-white image, here the treatment is different. Blumenfeld proposes two readings: close-up, allowing the grain of the photograph to take on materiality and autonomy; and far away, allowing the figure to come into view. This double vision is common to these two portraits.

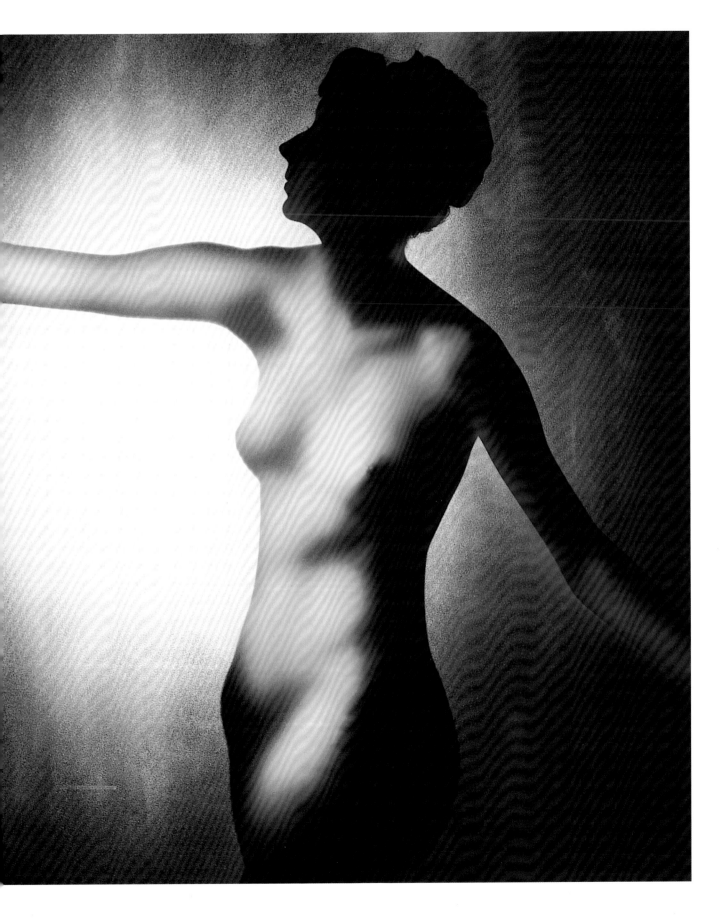

1944 The Virgin of New York, New York.

The transition to colour, which Blumenfeld made upon his arrival in New York, forced him to rethink both composition and lighting. Indeed, since Blumenfeld now was obliged to consign his printing to a laboratory over which he had no control, he would need to arrange the conditions of the photo shoot (pose, lighting, framing, effects) carefully and in advance. An example is the orange-pink light shown here, which produces an effect inspired by Expressionist film.

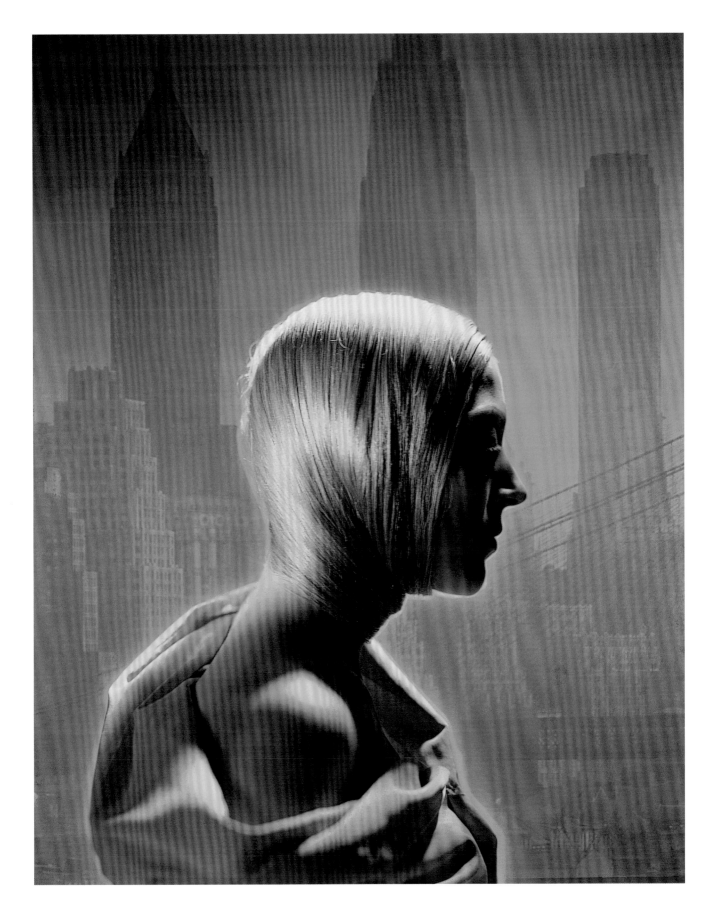

23 | c. 1944 | Virage Bleu, New York.

This photograph is the result of adding blue to a black-and-white, solarized photograph. The composition involves the repetition of a single element, a face given over to lighting effects; each repetition leaves different parts of the face obscured by shadow. The background, in the form of a stain, seems to have been determined by chance. Blumenfeld profoundly appreciated the imprint that chance leaves on things.

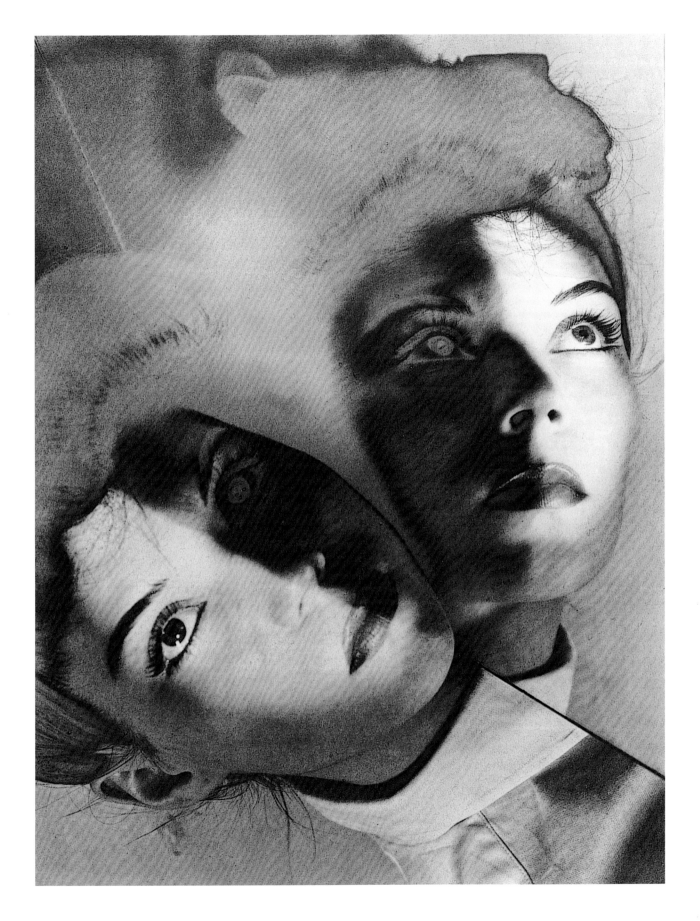

1944　　The Coca-Cola Chair, New York.

Coca-Cola provided bars with chairs made of spiralling stems of metal. This photograph contrasts the clear, lightweight design of the modern chair with the contours of the female nude. The black of the chair is juxtaposed with the white of the body, its playful cast with the roundness of a compact form that melts into the white background. The image illustrates the stress Blumenfeld placed on lighting in order to obtain graphic effects.

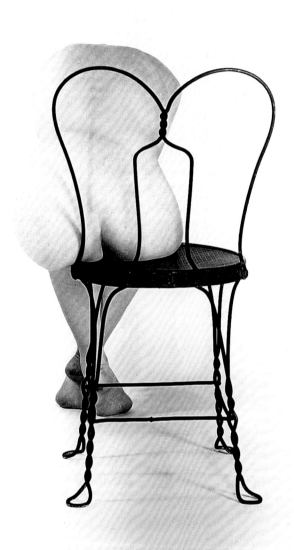

25 1944 Woman with Camellias, New York.

The vivid colours of the camellias stand out against the black background. The surface of the photograph seems strewn with flowers, between which the face and the arm of the model come into view. The decor has been set up in front of the camera before the photo shoot in order to produce the illusion. The model has probably been placed on her back, with the camellias delicately laid upon her.

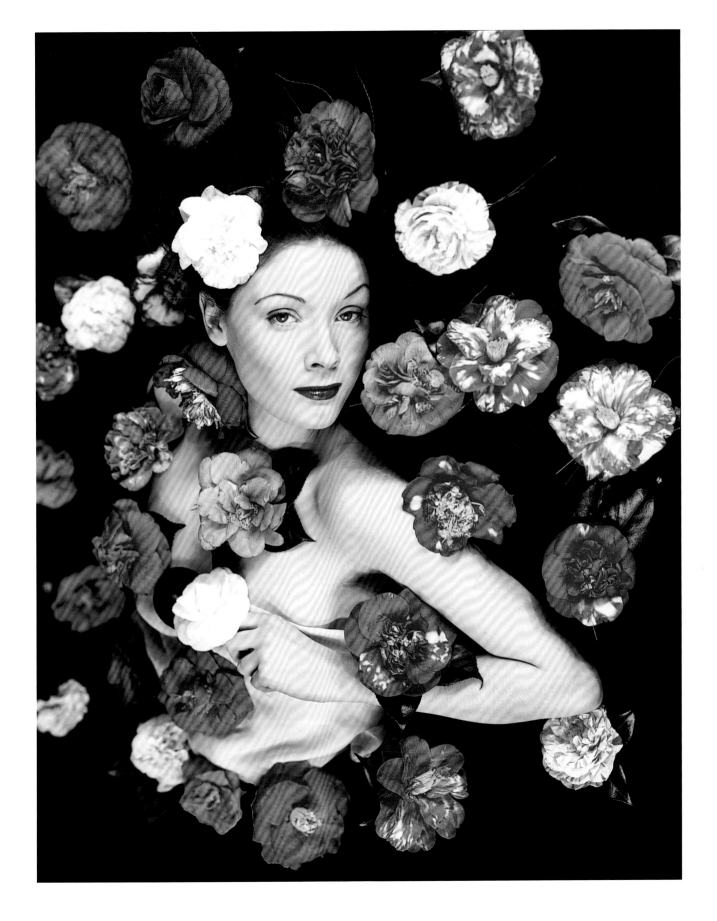

1945 | Golden Helmet, New York, 1945.

Blumenfeld returned to work for *Vogue* after leaving *Harper's Bazaar* in 1944. This photograph is one of his proposals for the May 1945 issue of *Vogue*. Here, in contrast to the other versions, the framing is narrower. The lighting emphasizes the relationship between the erotic elements – hair and lips – while the visor leaves the face and the eyes in shadow.

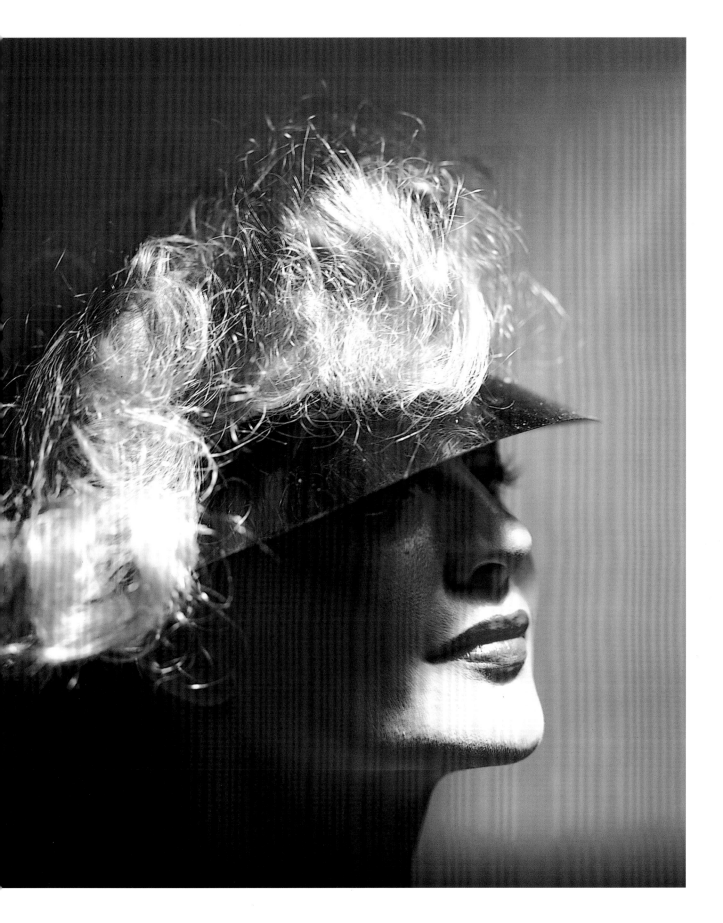

Red Cross, New York.

A model, a red cross: fashion and current affairs superimposed. The cover of *Vogue* (15 March 1945), for which this photograph was intended, carried two captions: 'Spring Fashions' and 'Do Your Part for the Red Cross'. The background to this humanitarian appeal is the liberation of the concentration camps and the aid brought to prisoners of war. Blumenfeld reinterprets these humanitarian signs just as he blurs those of fashion.

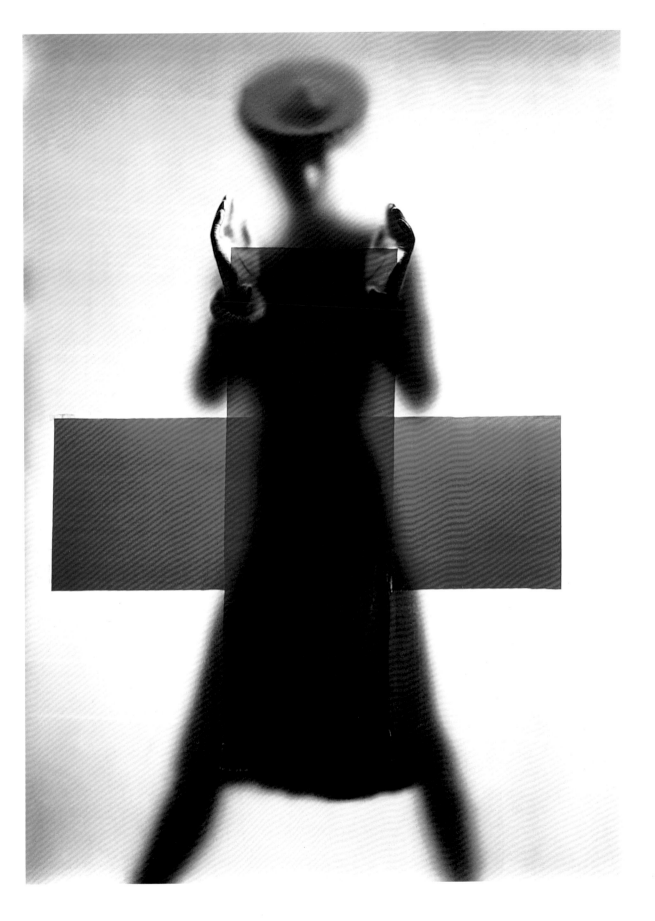

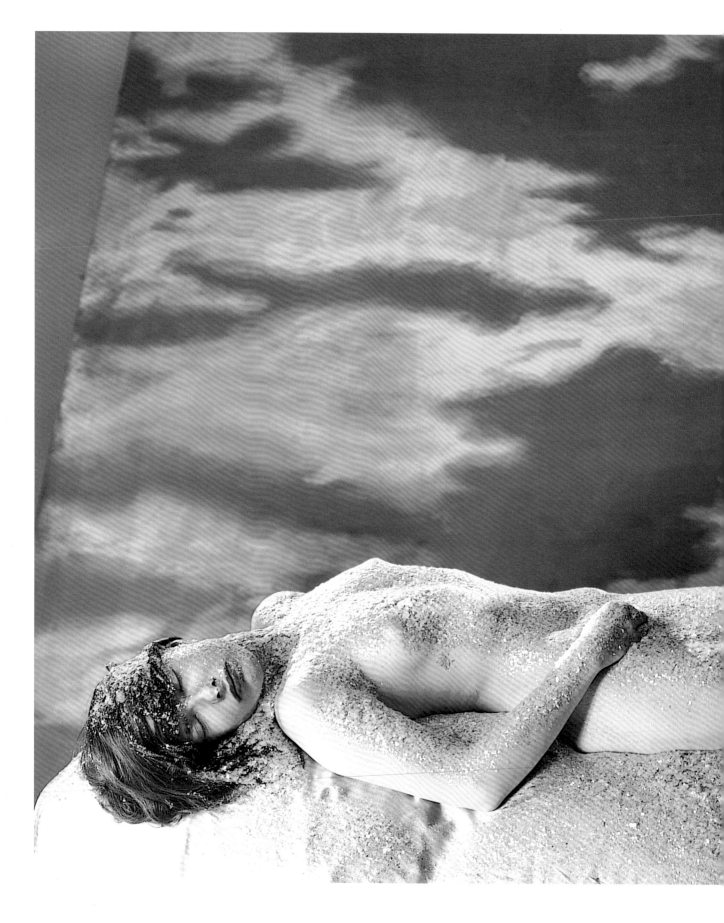

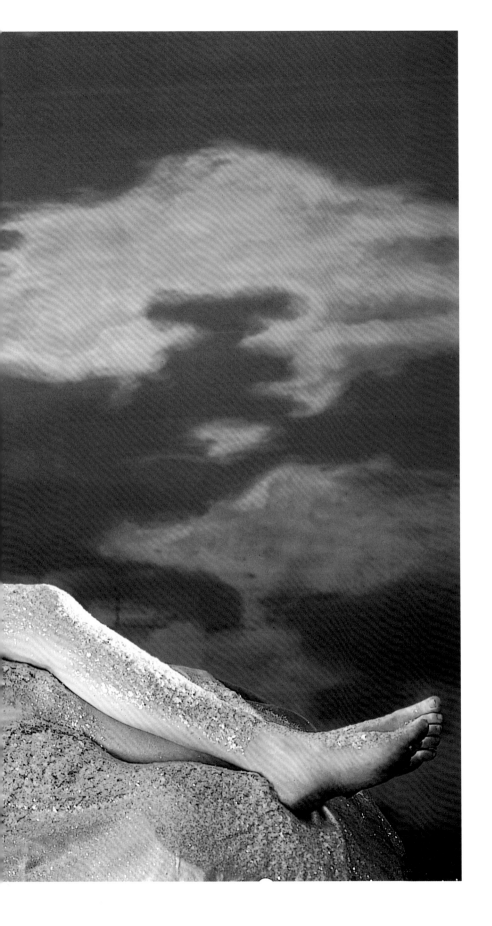

28 *previous page*	1945	Nude in Artificial Snow, New York.

In Blumenfeld's photographs, women often have their eyes closed; they look asleep, dreaming, absent from the world. In this, one can discern an affinity with Surrealism and its propensity for dream narrative, the unconscious, the accent placed on the irrational. This nude would seem to be inspired by Sir John Everett Millais's painting *Ophelia* (1851–2).

29	1946	Untitled, New York.

Fashion photography is not concerned with faithful documentation. On the contrary, its purpose for Blumenfeld was to produce the illusion of happiness. So it is with this happy woman in the cool of the evening on her New York balcony. The lights of the skyscrapers behind her are those of another photograph, which Blumenfeld combined with the first.

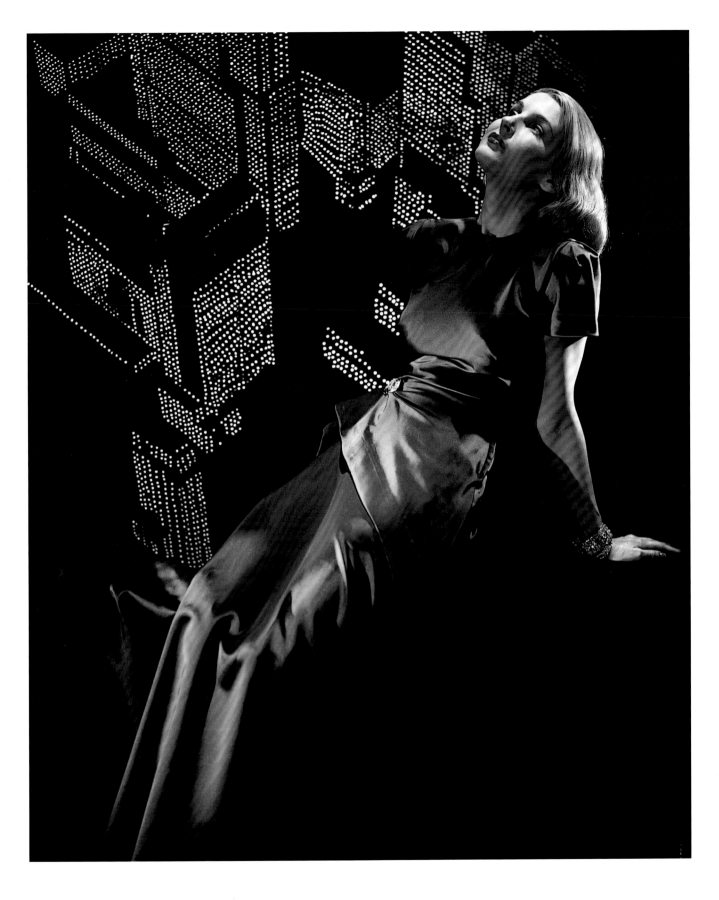

1946 Untitled, New York.

Teddy Thurman was one of Blumenfeld's favourite models. The model's
face, lit from behind, comes forward as if wrapped in a luminous halo.
The features dissolve into fluidity, the contours of the hair and the shoul-
ders become fuzzy in the light. All that remains is the outline of the
profile and the delicate gesture of the fingers stroking the chin. A red
filter placed on the lens plunges the scene into a dreamlike ambience.

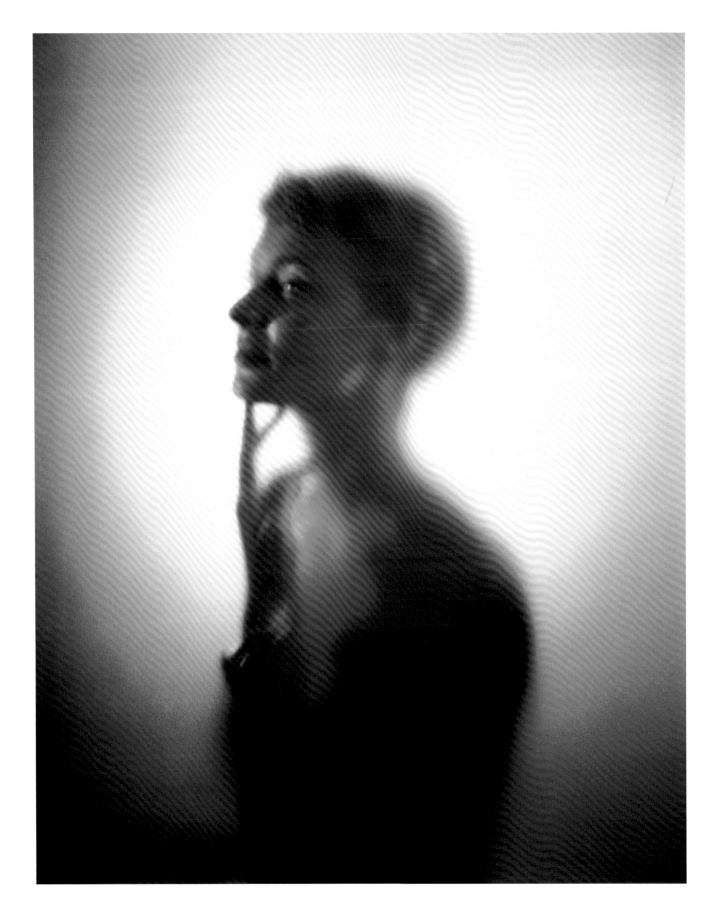

1947 Eugene O'Neill, New York.

Blumenfeld was now famous and magazines were commissioning portraits of celebrities and artists, such as the actress Marlene Dietrich, the singer Juliette Gréco, the film director Robert J. Flaherty and the dramatist Eugene O'Neill. But though he was able to impart a strong tension to the graphic composition of this photograph, Blumenfeld was usually more enthusiastic about photographing women.

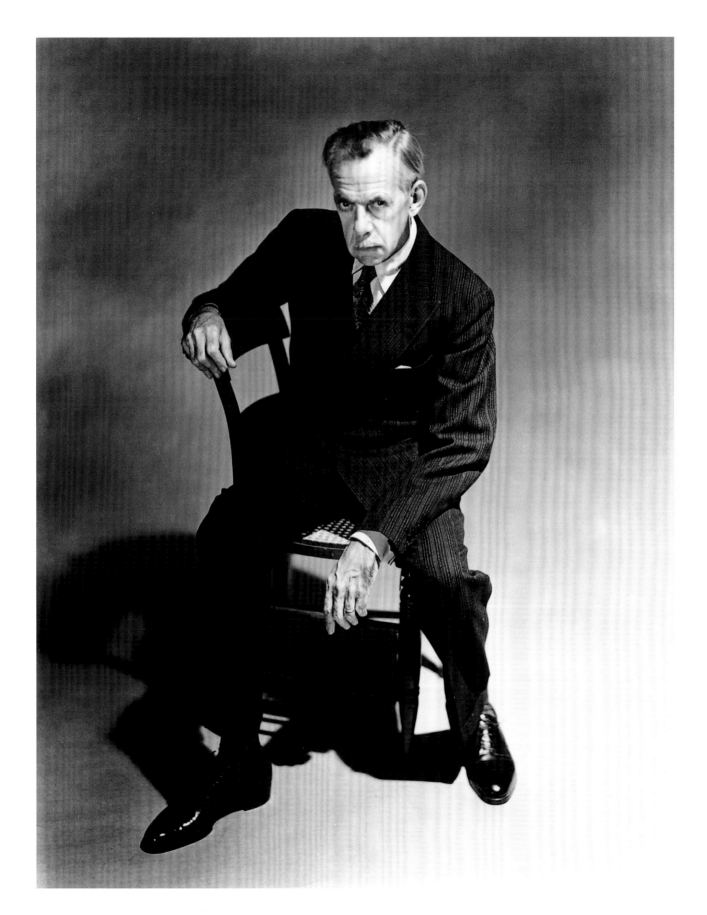

1947 | What Looks New, New York.

Blumenfeld explained, 'The problem here was to show new nuances of lipstick shades. The model [Teddy Thurman] was carefully placed in front of a broken mirror, the shattered reflection was photographed, and the colours of the lipstick were then retouched by the engravers.' This photograph is an alternative to the one that appeared in *Vogue* (15 March 1947) as an advertisement for John Frederic's beauty products.

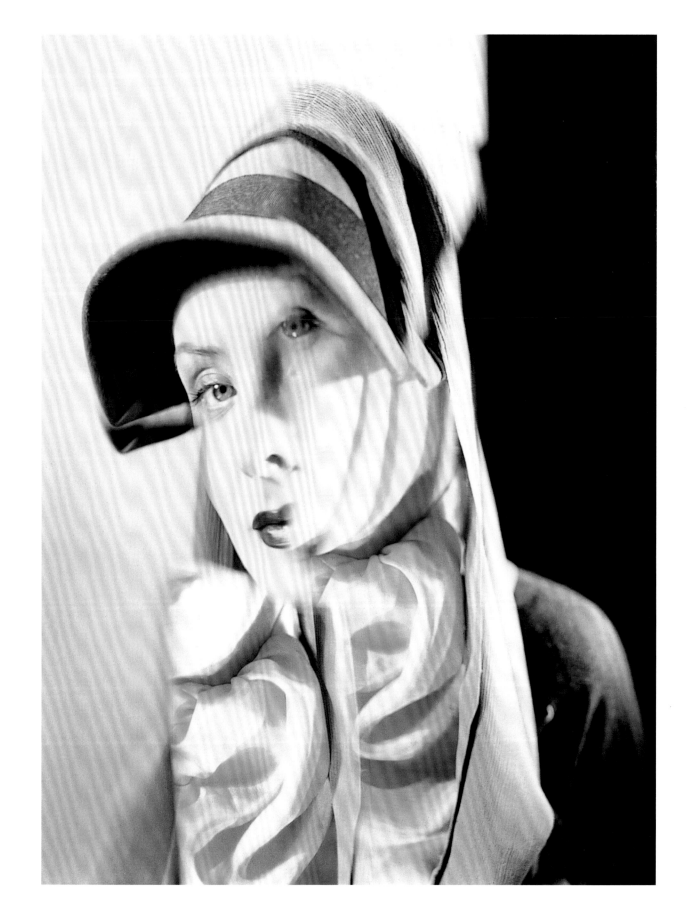

1947 | Three Graces, New York.

The model Leslie Petersen appears here in a triple variation inspired by Sandro Botticelli's painting *Primavera* (c. 1482). The photograph, which was never published in a magazine, was intended to show off an evening gown created by Cadwallader. The final image is made up of two shots. The two motifs on the right are similar, but do not show the same degree of sharpness. The pose on the left is different.

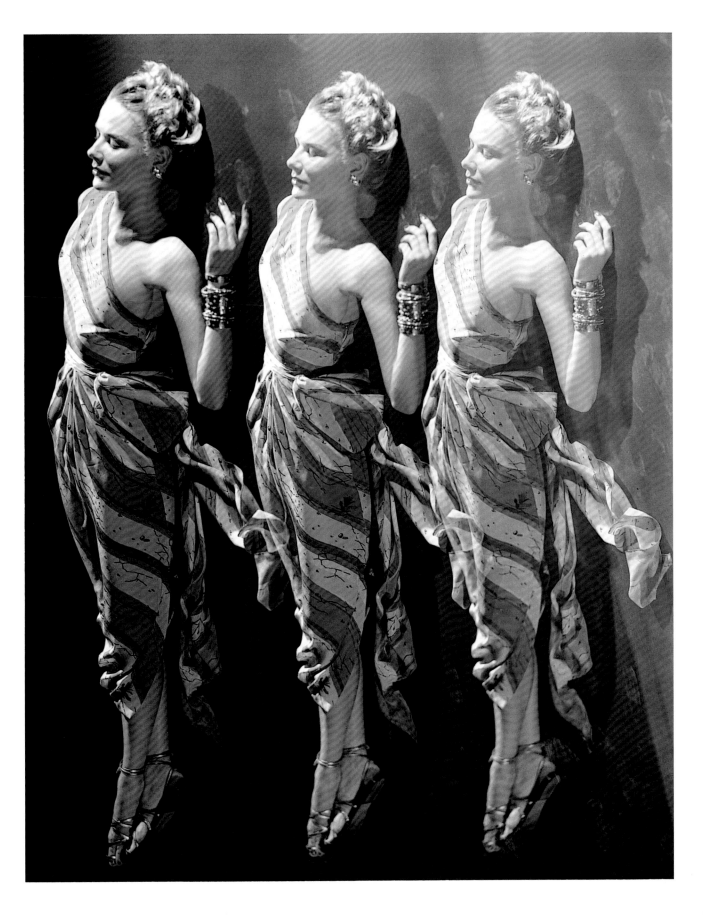

1949 Untitled, New York.

Blumenfeld continued with his own experiments in tandem with his
commission work. Here, inspired by Cubist painters, he puts together
an unsettling image through complex staging. Head, bust and arms are
disconnected, placed in opposition by their orientations, their contours
emphasized by luminous reflections. Taken as a whole, the photograph
gives the impression of an apparition.

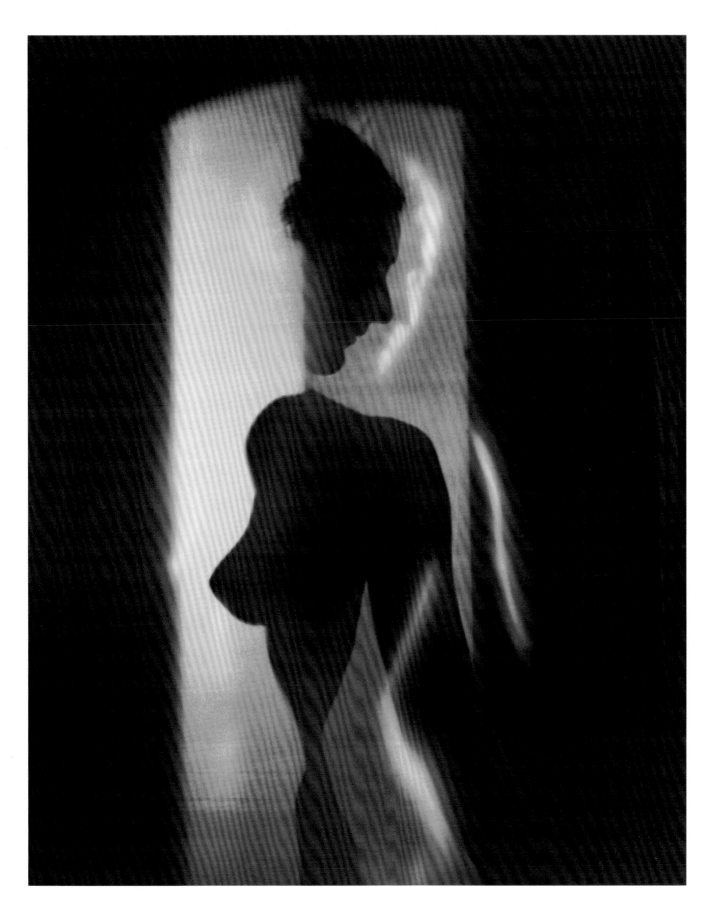

 The Doe Eye, New York.

This black-and-white photograph of the model Jean Patchett (coloured
by the art department of *Vogue*) dominated the cover of the January 1950
issue of *Vogue*. By means of broad and violent lighting, Blumenfeld erased
all the features of Patchett's face, leaving only the most minimal details:
an eye, the mouth and a beauty spot. This composition has subsequently
been widely imitated.

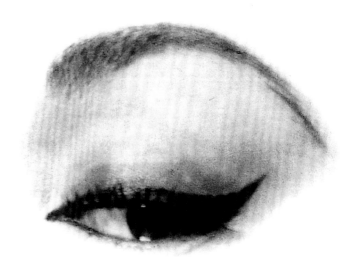

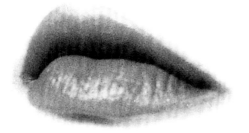

1950 Woman with Parasol, New York.

For the cover of the 15 March 1950 issue of *Vogue,* Blumenfeld made several proposals, as was his habit. *Vogue* rejected this photograph in favour of a close-up of the bust, accentuating the make-up, the pearl necklace and the hat and coat worn by the model. Here, by contrast, thanks to the treatment of negative space and the quasi-uniformity of colour, Blumenfeld introduces an intriguing calm into the photograph.

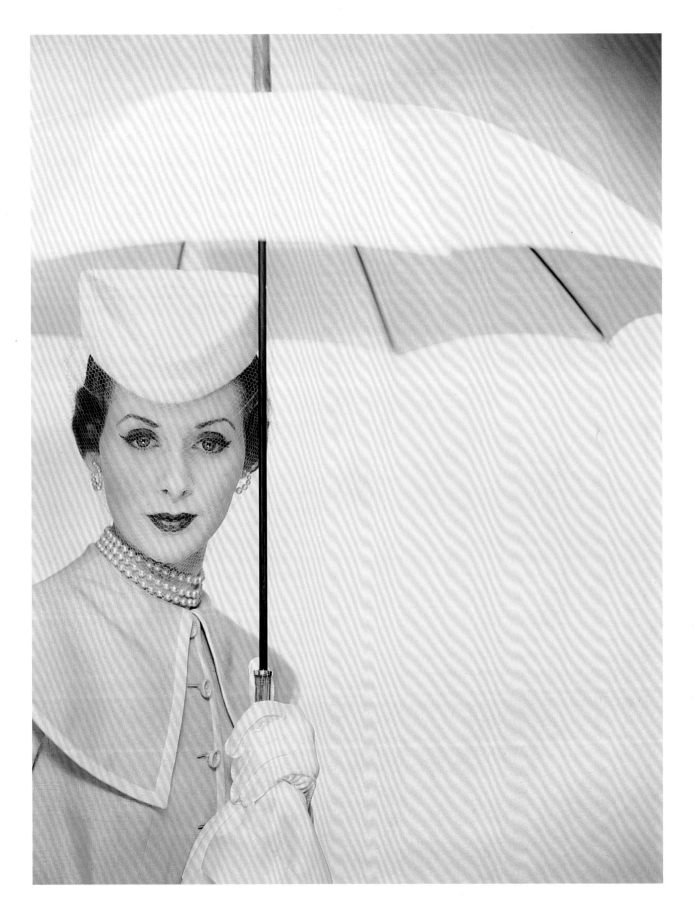

| 37 | 1951 | Blue Veil, New York. |

This photograph was the result of a commission that was ultimately refused. It was published for the first time as the cover of William A. Ewing's book *Blumenfeld: a Fetish for Beauty* (1996). The veil, which covers the face of model Leslie Redgate, is a recurring motif in Blumenfeld's work. The thin veils in Renaissance paintings by Sandro Botticelli and Lucas Cranach the Elder had attracted Blumenfeld since childhood. In the early 1930s, inspired by the Northern Renaissance painter Rogier van der Weyden, Blumenfeld produced a photograph quite similar to this one.

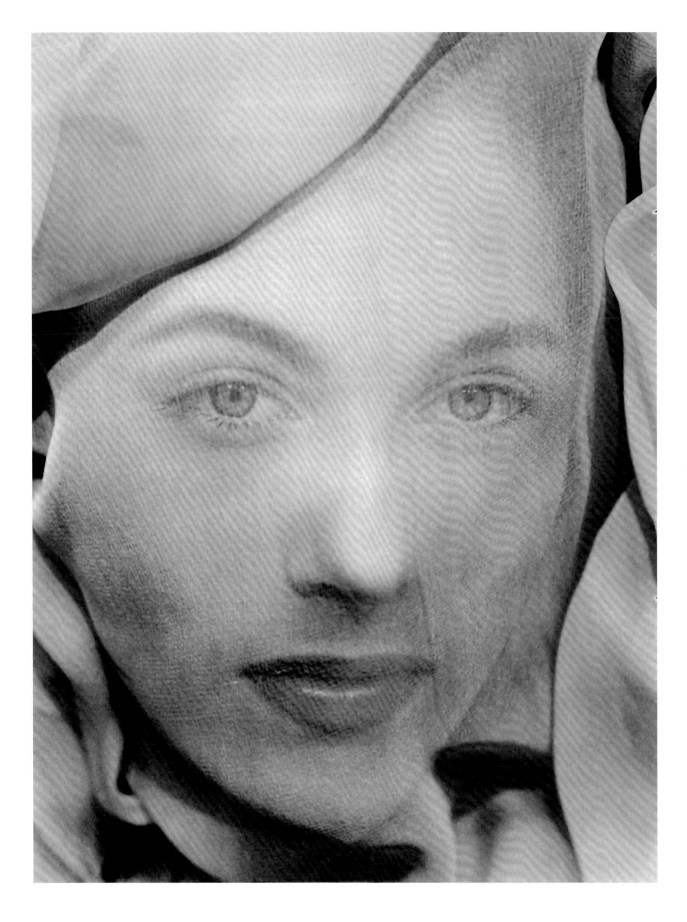

c. 1952 Audrey Hepburn, New York.

When she posed for this photograph, Audrey Hepburn had just begun her film career (the following year she starred in *Roman Holiday*). She is wearing a hat designed by Blumenfeld and made by Mister Fred, one of New York's most talented milliners. Blumenfeld here uses a system of mirrors showing the front and back of the hat and allowing infinite repetition of the motif.

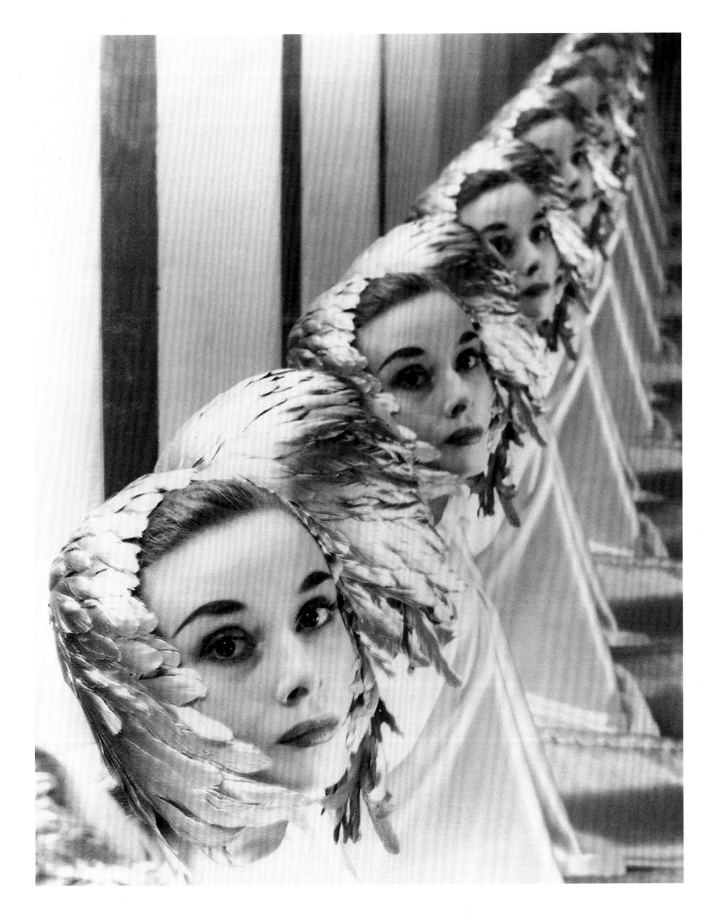

1952 Grace Kelly, New York.

The actress Grace Kelly is pictured here in the year she starred in *High Noon*. The portrait is the result of a commission from *Cosmopolitan* magazine. Blumenfeld creates a rigorous but supple geometrical composition. Kelly occupies the diagonal of a frame and covers the lower left-hand side of the image, forming a triangle. Her arm and head form a second triangle laid softly on the first.

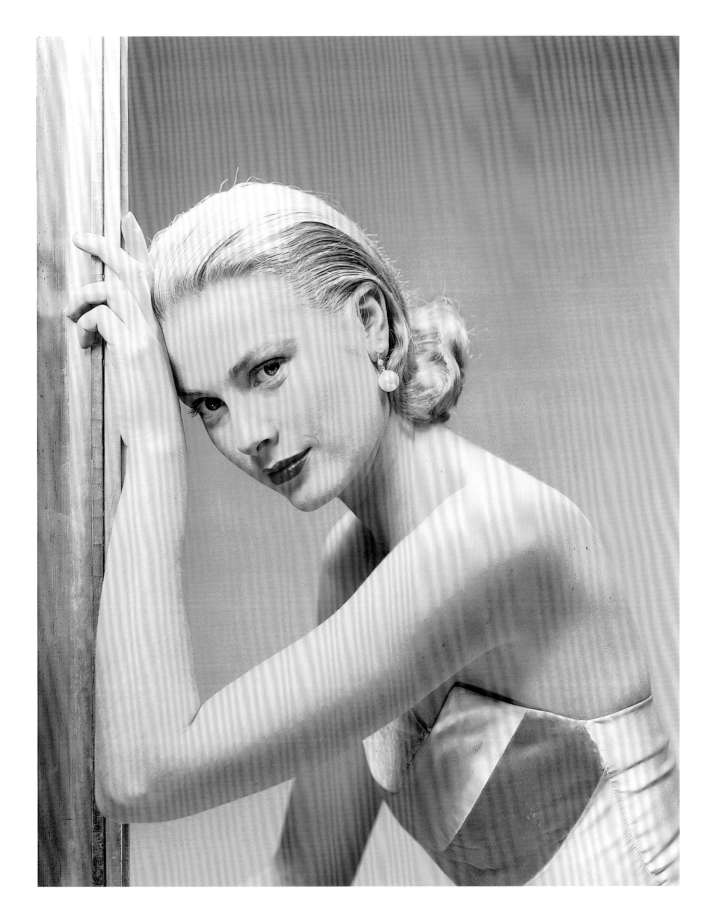

40 1952 Décolleté, New York.

This photograph is similar to one that appeared on the cover of *Vogue* on 15 October 1952. The caption to the photograph read, 'This face, wearing the mask of *Vogue* – whose is it? It might belong to any American woman. The lipstick is her inevitable signature ... Foundation and lipstick by Elizabeth Arden.' The dress is by Jacques Fath.

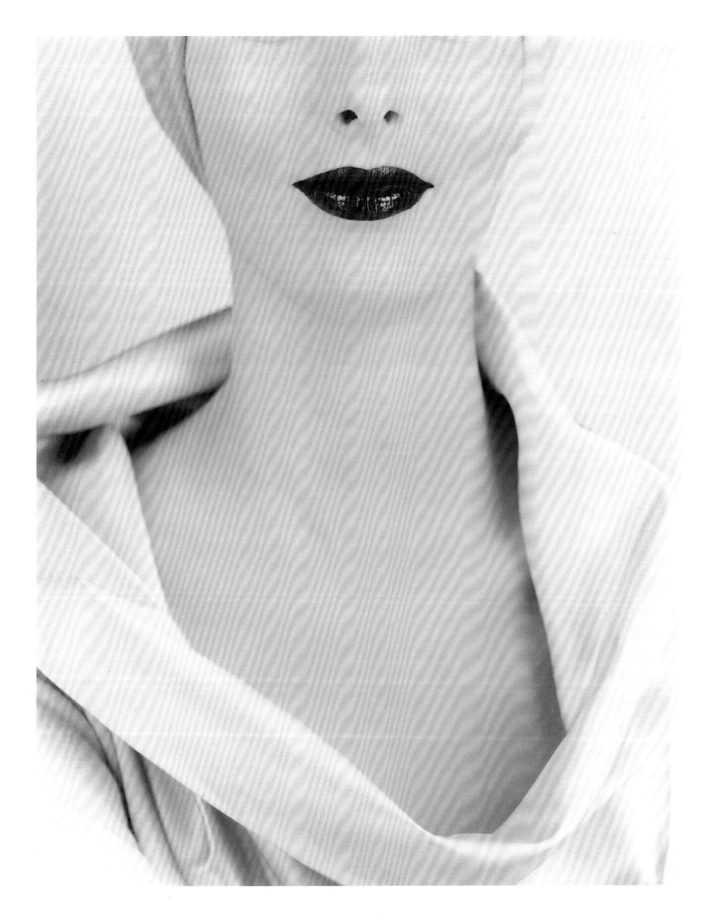

41　　　　　　　　　1952　　|　　Hat with a Green Rose, New York.

With model Nina de Voogt, Blumenfeld prepared this photograph for
the cover of an issue of *Vogue* (15 February 1953) dedicated to thirty
new hats decorated with chiffon roses in spring colours. The art direc-
tor preferred a version showing the rose from the front and the model
in profile, in which only an eye, shaded by the green shadow of the
rose, and a corner of the mouth can be seen. The final cover lacked the
striking double framing of this image.

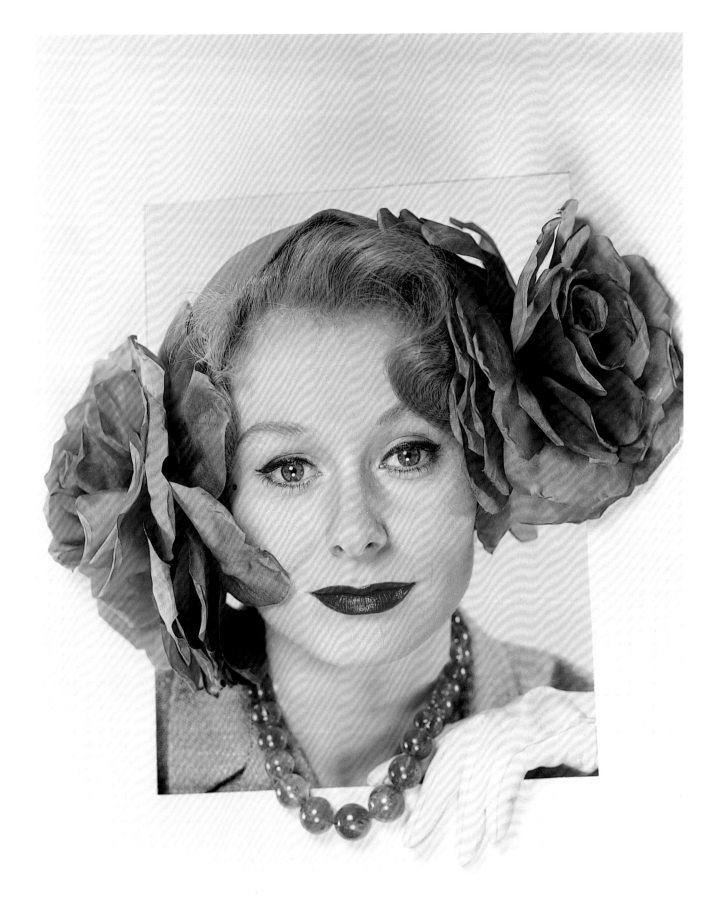

1952 Untitled, New York.

After a photo session dedicated to lingerie made by Lily of France,
Blumenfeld took the opportunity to have a bit of fun, photographing
model Ruth Knowles in a decor made up of his own black-and-white
photographs. The images cover the surface of a screen. This gesture
shows how closely linked commissioned work and personal experi-
mentation were for Blumenfeld.

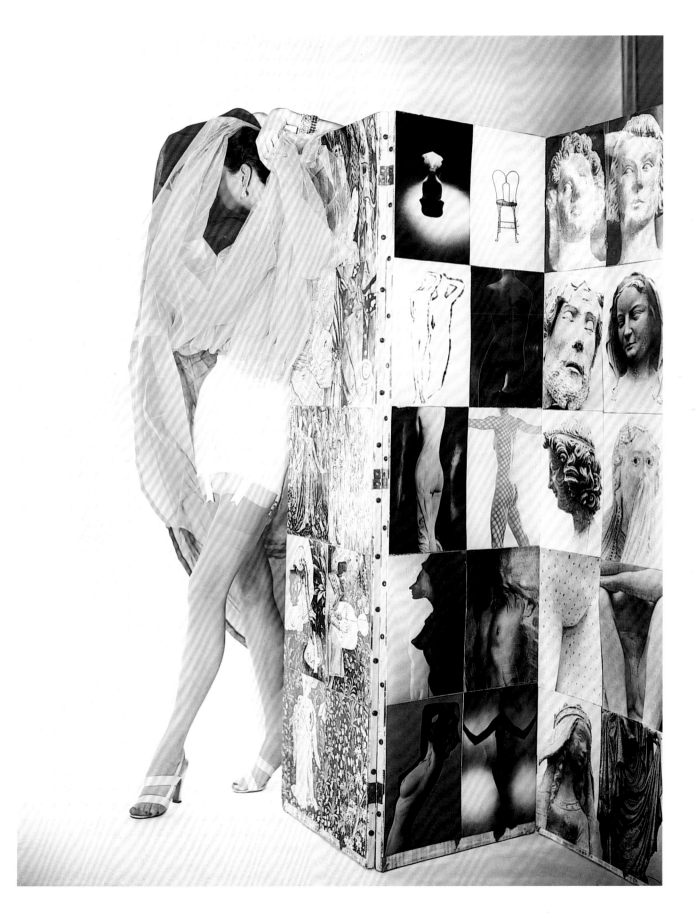

1952 O, New York.

Taking inspiration from Arthur Rimbaud's poem 'Sonnet of the Vowels'
(1871), Blumenfeld had the idea of creating a series of photographs after
the French poet's conception of linking sound and colour. This theme
allowed Blumenfeld to concentrate on one of the body's most erotic zones:
the lips. Painted, shining, round and protruding, the red lips are more
than just the locus from which words escape; their shape coincides with
the very shape of the vowel sound they are making.

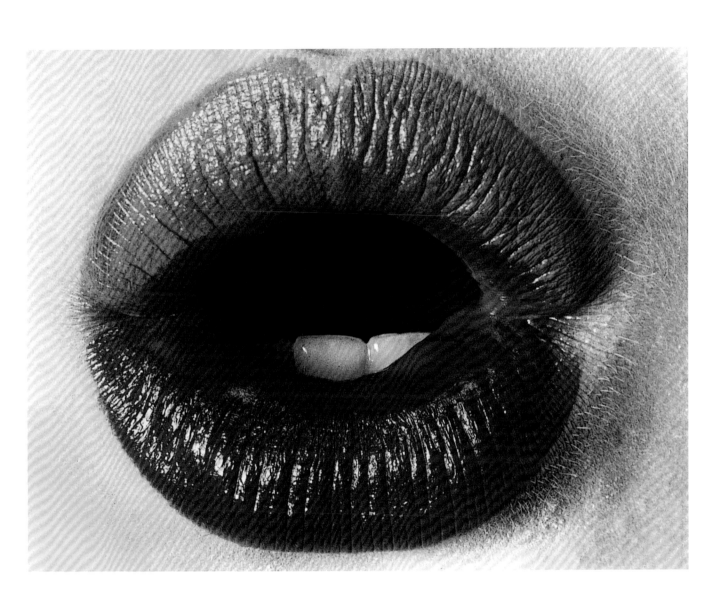

1953 Jacques Fath Dress, New York.

This photograph is part of a series prepared by *Vogue*. It shows the model Evelyn Tripp in a dress by Jacques Fath. It was one of Blumenfeld's favourite images in the series because of its simplicity. The slight movement of the model is accentuated. Partially hidden by translucent glass, she reveals only her face. Lipstick and the carnation in her pocket capture the viewer's gaze.

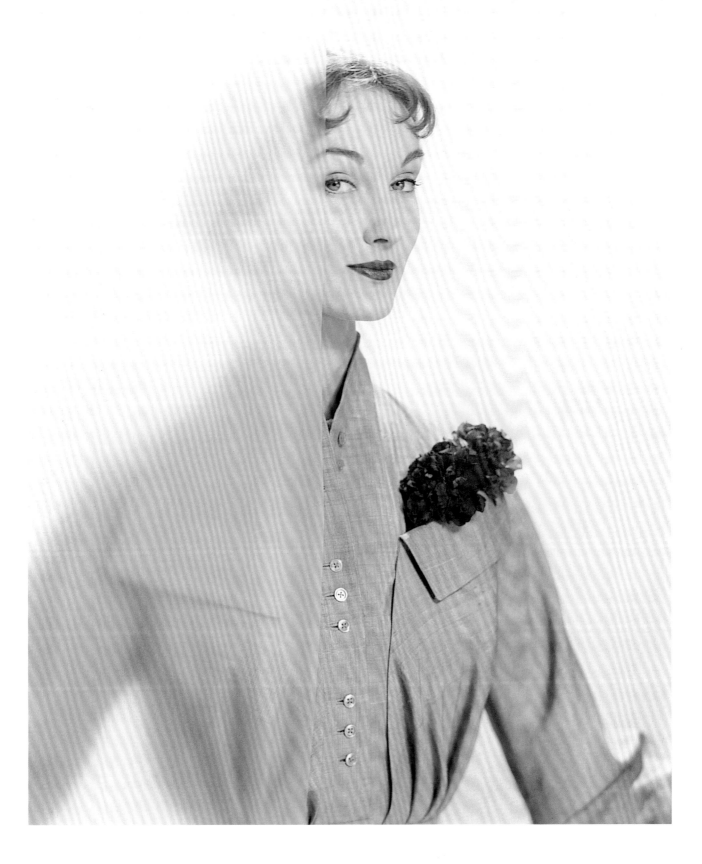

45 1953 Untitled, New York.

Blumenfeld always tried to introduce and revise techniques he had developed
through his years of experience: mirrors, veils, distortions, glass surfaces,
filters and lighting. In this portrait of the model Dovima, intended for the
cover of *Vogue*, Blumenfeld relies on his masterly control of lighting. The
photograph was taken through a rippled glass pane. The bubbles in the glass
appear as small dots on the photograph.

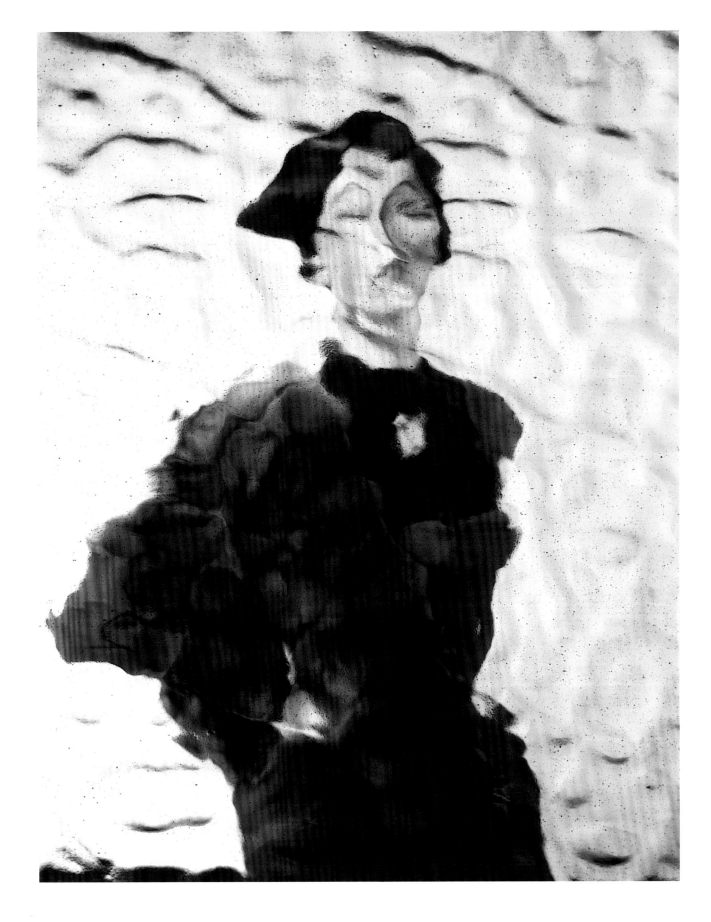

1954 Singer in Blue, New York.

Blumenfeld always regarded himself as a 'Sunday painter'. He created
the painting in the background of this image specifically for this photo
shoot. Blumenfeld intended to create for the photograph a harmony of
blues, balanced shade for shade. Here the contrast is between the matt
surface of his painting, the shade of the eye make-up and the colour of
the dress, its changing reflections caught by the light.

47 1954 Red on Red, New York.

Vogue, which considered itself a pioneer of colour photography, dedicated a
double-page spread to Edward Steichen's colour photographs as early as 1935.
Blumenfeld continued in this tradition, experimenting with the palette of
his favourite painters: Manet, Van Gogh and Vermeer. Originally in 'Red
on Red', Blumenfeld wanted to show different nuances of the same colour.
Fading has made these differences less distinct. The model is Evelyn Tripp.

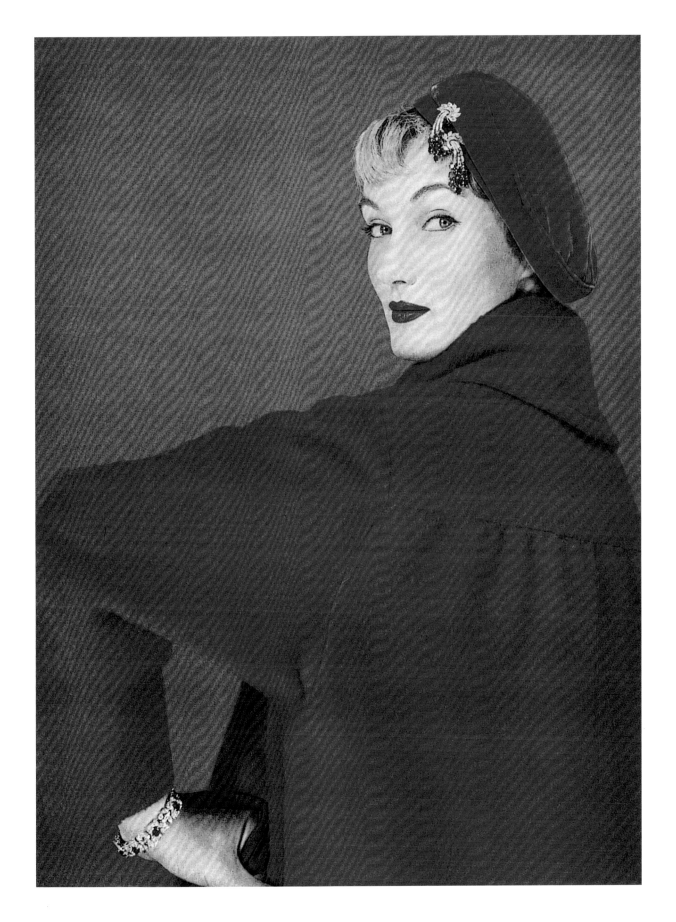

48 1954 Spanish Coat, New York.

Blumenfeld did not hesitate to contribute suggestions to *Vogue* even
as he fulfilled his commissions for the magazine. Here, for example,
Blumenfeld photographed a coat by a young Spaniard who had come
to show him his work. The photograph was refused – the editors
were not interested in showing the work of unknown designers. The
choice of the model, Nancy Berg, is the result of a chance meeting –
she had never worked for Blumenfeld before.

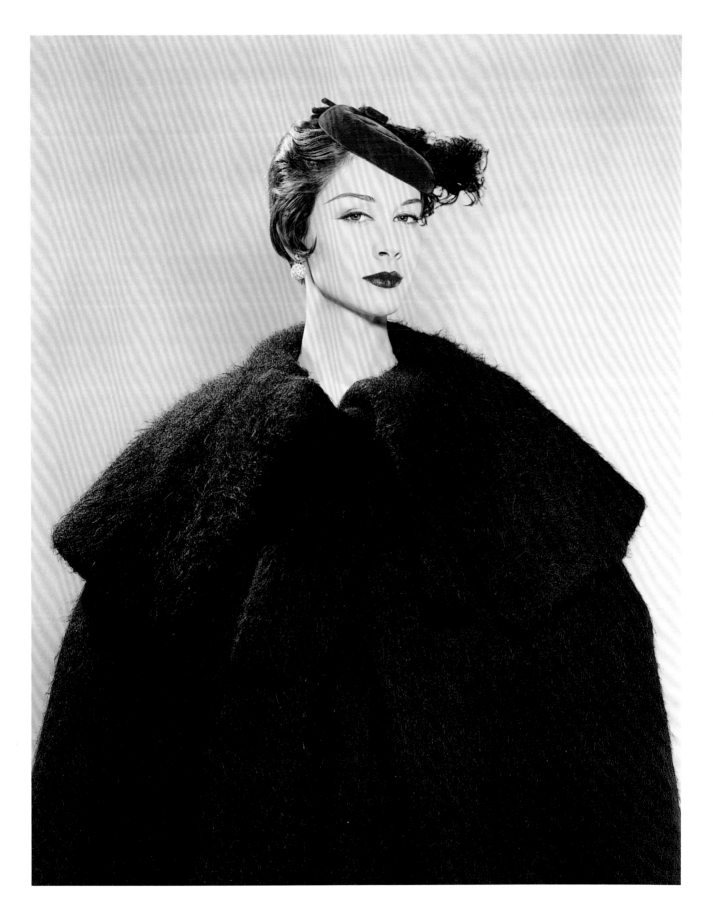

1954 Marlene Dietrich, New York.

Originally from Germany, the film actress Marlene Dietrich shared with
Blumenfeld the culture of Berlin. Their meetings offered them the chance
to speak in dialect. Blumenfeld particularly emphasized the glamorous
character of his model. A slight, luminous halo sets off her delicate silhou-
ette and gives a silken aspect to the fur and the dress. Dietrich's haughty,
languorous gaze searches out and stares down the lens, dominating it ulti-
mately with charm and gentleness.

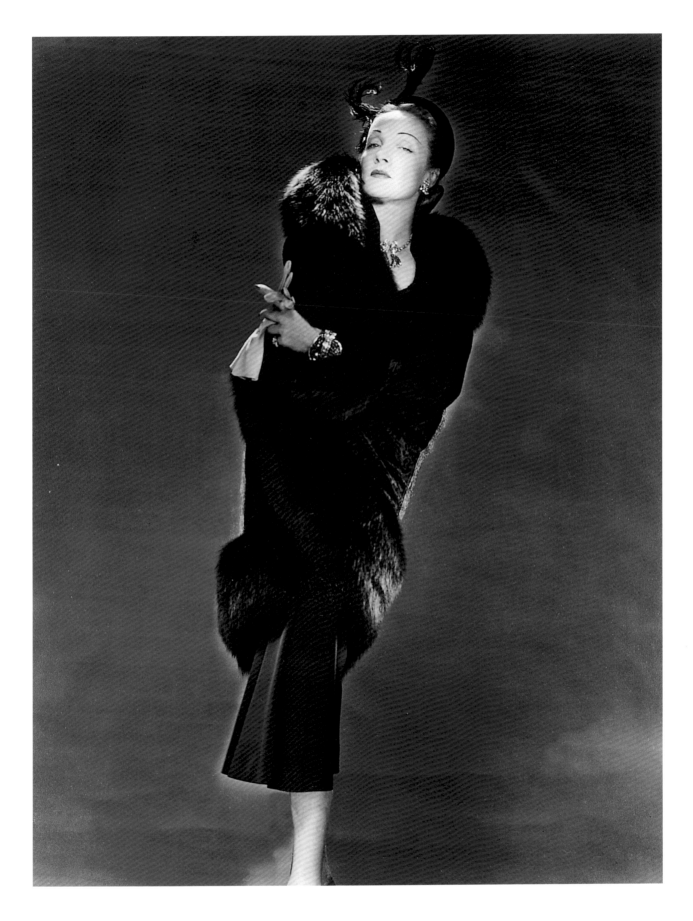

1957 Bani, New York.

Bani Yevelston was the first black model to participate in an American fashion show. Her appearance in Minneapolis made a big splash and was the subject of a number of press articles. The *New York Times* reported the event and *Life* magazine published a series of photographs by Blumenfeld illustrating the dresses and models in the show.

Kathleen, New York.

Kathleen was responsible for hiring models for *Vogue*. In 1955 she became Blumenfeld's agent, and the following year she married his son Henry. She recalled that Alexander Liberman, art director of the magazine publisher Condé Nast, asked her to treat Blumenfeld with great care and respect because he was their prize possession. This portrait is a study for a later work for the Dayton department store in Minneapolis (see following pages). Blumenfeld here used the Kodalith process, which accentuates contrasts and eliminates greys.

c. 1960 Dayton's Oval Room, New York.

In the 1950s, Blumenfeld developed an excellent working relationship with Stuart Wells, vice president of Dayton's department store in Minneapolis. The Oval Room was the store's designer boutique. Wells gave Blumenfeld complete artistic freedom. He could choose themes, clothes, models and decors and even determine the layout of the image on the page. In this photograph, Blumenfeld took full advantage of the opportunity, working with contrasts, textures and his motif of doubling and splitting images.

1961 Dayton's Oval Room, New York.

For Blumenfeld, his contract with the Dayton department store nourished his artistic renewal. During this period, Blumenfeld returned to his beloved black and white, eliminating the greys and underlining the forms by heightening the contrast. The technique recalls Matisse's work with cutouts in the last period of his life. Blumenfeld's image gains a graphic look; the photograph loses the detail of the grain and is transformed into a drawing that accentuates movement.

1962 Nadia, Loveladies, New Jersey.

Nadia Blumenfeld, the photographer's granddaughter, acted here as a model for a brand of shampoo. This photograph, unpublished until now, is one of the very few formal pictures that Blumenfeld made in an outdoor setting and one of only two in this book (the other is 'The Eiffel Tower', no. 17). Indeed, few published photographs were made outside a studio setting. However, he took many outdoor family pictures and thousands of slides on his travels around the world.

| 55 | 1968 | Kabuki, New York. |

Blumenfeld repeats the face of the model several times and spreads it out over the image like a deck of playing cards. The accentuation of contrasts and the modification of proportions, resulting from the use of a wide-angle lens, create the impression of great distance from the model and impart the sense of masks. This photograph is one of the last images made by Blumenfeld and has not previously been published.

1897	Born in Berlin on 26 January.
1903	Meets artist Paul Citroën, who would become a lifelong friend.
1913–16	Father Albert dies in April 1913. Blumenfeld becomes an apprentice to Moses and Schlochauer (womenswear manufacturers) in Berlin.
1915	Has first contact with the Dadaists, befriends painter George Grosz.
1917–18	Serves in World War I as an ambulance driver and is decorated for his actions. Brother Heinz dies on active service. Tries to desert, is arrested and returned to the front.
1918	Rejoins his fiancée Lena, cousin of Paul Citroën, in the Netherlands.
1919–21	Begins dealing in contemporary art with Paul Citroën and joins the Dadaist movement. Makes collages, paints, writes poems and stories.
1921	Marries Lena Citroën with whom he has three children: Lisette, Heinz (Henry) and Frank Yorick (born 1922, 1925 and 1932 respectively).
1923	Opens a leather goods shop in Amsterdam specializing in handbags.
1932	Opens a new store in which he discovers a darkroom. Attempts to make a living as a photographer. Holds first exhibition in Amsterdam.
1935	Store goes bankrupt. First photographs are published in the supplement of *Arts et métiers graphiques*. Has group exhibition in Amsterdam with Grosz, Umbo, Man Ray, Moholy-Nagy, among others.
1936	Moves to Paris and takes his first advertising photographs. Exhibits photographs in the Galerie Billiet. Rents a studio at 9 rue Delambre.
1937	Publishes photographs in *Votre Beauté*, *Verve*, the American magazine *Coronet* and the English magazine *Lilliput*.
1938	Cecil Beaton introduces him to editors at French *Vogue*.
1939	Photographs Eiffel Tower with Lisa Fonssagrives (no. 17). His contract with *Vogue* is not renewed and he travels to New York where *Harper's Bazaar* gives him a contract to cover Parisian fashion. Returns to Paris just before the start of World War II. Is interned as a foreigner in the French concentration camps at Vernet d'Ariège and Catus.

1941	Leaves France for the United States where he shares a studio with fellow photographer Martin Munkácsi. Publishes his first colour cover for the December issue of *Harper's Bazaar*.
1943	Opens a studio at 222 Central Park South. Publishes photographs in American and European editions of *Harper's Bazaar*, *Life*, *Look* and *Cosmopolitan*. His photomontage of German Nazi leader Adolf Hitler (no. 04) was used as an Allied propaganda leaflet the previous year.
1944	Leaves *Harper's Bazaar* to return to *Vogue* in New York.
1947–8	Selection of his works is presented at a joint exhibition organized by Edward Steichen at the Museum of Modern Art, New York and later at the Museum of Los Angeles (now Los Angeles County Museum).
1950	'The Doe Eye' (no. 35) is published as the cover for American *Vogue* and becomes his best-known photograph.
1952	Takes publicity photographs for Dayton department store, Minneapolis.
1955	Ends his work for *Vogue*. Produces many photographs for advertising. Begins to write his autobiographical novel, *Einbildungsroman*. Experiments with printing Cibachrome photographs.
1962	Tries making motion pictures, hoping to use them commercially.
1969	Prepares a selection of his work for *My 100 Best Photographs*, which contains only four of his fashion pictures. Dies on 4 July in Rome.
1975	Publication of French translation of *Einbildungsroman* as *Jadis et Daguerre*. The German edition appears a year later as *Durch tausendjährige Zeit*.
1979	Publication of *My 100 Best Photographs* in German and English.
1981	Exhibition of fashion photographs at Musée Pompidou, Paris.
1996	*Blumenfeld, a Fetish for Beauty* by William Ewing is published, with a retrospective exhibition at the Barbican Centre, London.
1999	Publication of English translation of autobiography *Eye to I*, and *The Naked and the Veiled* by Yorick Blumenfeld.

Front cover
Décolleté, New York.
1952 (see no. 40)

Phaidon Press Limited
Regent's Wharf
All Saints Street
London N1 9PA

Phaidon Press Inc.
180 Varick Street
New York NY 10014

www.phaidon.com

First published 2004
© 2004 Phaidon Press Limited

ISBN 0 7148 4193 5

A CIP record of this book is available from
the British Library.

Translation by Matthew Gaskins
Designed by Pentagram
Printed in China